Postcard History Series

West Orange

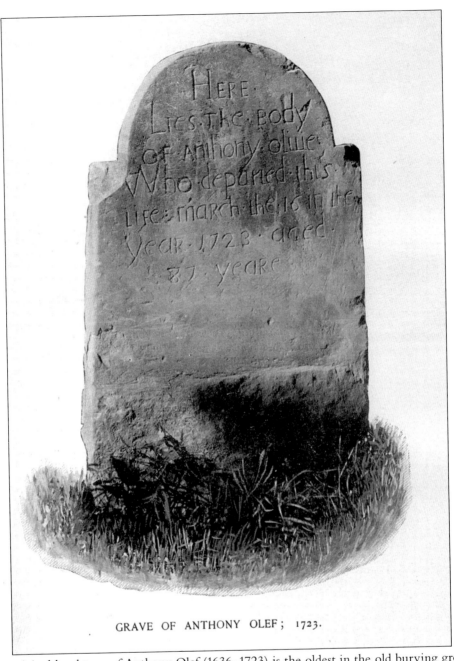

GRAVE OF ANTHONY OLEF; 1723.

The original headstone of Anthony Olef (1636–1723) is the oldest in the old burying ground in Orange and possibly even Essex County. It could be said that Olef was West Orange's first resident. He lived on the eastern slope of the first mountain in what was then considered a wilderness. His home was once located in what became Llewellyn Park more then 130 years after his death. (Author's collection.)

On the front cover: Please see page 12. (Author's collection.)

On the back cover: Please see page 118. (Author's collection.)

POSTCARD HISTORY SERIES

West Orange

Joseph Fagan

ARCADIA
PUBLISHING

Published by Arcadia Publishing
Charleston SC, Chicago IL, Portsmouth NH, San Francisco CA

Printed in the United States of America

Library of Congress Control Number: 2008936589

For all general information contact Arcadia Publishing at:
Telephone 843-853-2070
Fax 843-853-0044
E-mail sales@arcadiapublishing.com
For customer service and orders:
Toll-Free 1-888-313-2665

Visit us on the Internet at www.arcadiapublishing.com

Dedicated to the memory of my dear parents, James and Helen Fagan.
Like all history, they too now belong to the ages.

CONTENTS

ACKNOWLEDGMENTS

All images appear courtesy of the author. No acknowledgment of this work could be complete without the brief mention of my family's West Orange history. My great-grandfather Richard Fagan was born in Orange about 1868. He grew up and lived in Orange and West Orange but died before I was born. His son, my grandfather James Fagan Sr. (see page 26), was born in 1901 and also lived in Orange and West Orange. Perhaps it was a chance visit to the bank in West Orange center (see page 25) with my grandfather in 1964 that truly made this book possible. It was on that occasion, as an impressionable seven year old, that he introduced me to the large colorful wall murals overlooking the bank lobby relating to West Orange history. They are still displayed there, and they are what sparked my interest. It propelled me forward on a relentless search of knowledge about my hometown. Although not fully understood nor appreciated at the time, my awareness of West Orange's rich history began on that day. My father, James Fagan Jr. (see page 126), is now deceased but was born in 1921, and the only address he ever had was in West Orange with the exception of seven of his 82 years. They all have served as a constant source of inspiration in the writing of this book. Mere words cannot begin to express the posthumous acknowledgment they so rightfully deserve. I am totally confident that they would look upon this book with much favor and interest with a reassuring smile and nod of approval.

Finally, I would like to acknowledge my son Joseph and my wife Debbie. She and I first met as classmates at Mountain High School in West Orange in 1974. To her, I owe the deepest measure of gratitude for both her understanding and support in all my worldwide ventures and her immeasurable devotion as a wife and friend for more than 30 years.

INTRODUCTION

It has been said that home is where the heart is. Regardless of where one may live or travel, the fondest memories seem to migrate to the town of one's childhood. This is true of West Orange because my personal family history spans four generations here. I grew up here, and it will always remain special and be where home is in my heart. As time can distort memories, we begin to overlook all that is familiar. Changes begin to occur that are obvious, but others easily fall below our threshold of awareness. We often take places we pass on a regular basis for granted. Their existence becomes so obscured by our daily activities that we soon forget. However, an old family photograph can cause instant excitement as it takes us back to a specific place and time. The same experience occurs when certain buildings, landmarks, or even familiar street corners are seen in vintage postcards. Each one is a hidden treasure that allows us to explore and discover our past through images that capture a moment in time.

At the dawn of the 20th century, the Oranges participated in a spectacular weeklong celebration. It was a well-documented and much-photographed event. In fact, hundreds if not thousands of vintage postcards of the parade down Main Street through the Oranges were commercially produced. The centennial celebration of the Oranges in 1907 commemorated the first town meeting of 1807. The genesis for all the Oranges can be derived from that first town meeting of 1807.

The centennial committee of 1907, led by president David L. Pierson, had a specific vision to the future and an acute awareness of its purpose. It wanted to not only celebrate but also preserve the history of the Oranges for the future. It recognized that its mission in 1907 was not just about 1907. The members wanted their voices to be heard to help people of the future years understand their place and time. The committee's mission is best understood by paraphrasing the poem "To the Unborn Peoples," written by Ellen M. H. Gates in the 1907 program of the centennial celebration. She wrote, "Ye peoples of the future years, We you salute, to you we fling, a greeting glad. While yet we cling, to earth's old rim, we think of you. Hail ! Hail ! Ye peoples yet unborn, we leave you all that love bequeaths. Above our dust your songs will swell; Hail ! Hail ! and then, farewell . . . farewell." Gates is politely reminding us that we are only stewards of time and that one day it will pass.

West Orange is inspired and written in Gates's exact spirit to capture and document the history of the last century through vintage postcards for a new generation and the yet-unborn people to experience. Hopefully, 100 years hence, this will be viewed as a timeless and worthy reference, proudly documenting the progress of an unborn generation that has come of age and helping the people of the future to understand this place and time. Perhaps this book will play a role

in linking the past to the present and future, like a message in a bottle cast out on the vast sea of time waiting to be washed up on a distant future beach of tomorrow. The cable cars are no more, the trolley tracks have been paved over, and the sound of the train whistle has gone silent, but this was West Orange and this is its story.

Viewing vintage postcards of Main Street in West Orange can be a bit confusing. At one time, it was known as Valley Road. When it became Main Street in West Orange about 1925 it provided for a continuous flow of Main Street from East Orange through Orange and into West Orange.

Washington Street received its name in 1832. It was named to honor Gen. George Washington and his soldiers who had stopped at the old Harrison homestead that was located in that vicinity. Before it became Washington Street, it was known as the Swinefield Road. When it changed from the Swinefield Road in 1832, Eagle Rock Avenue most likely also received its name then.

The oldest route west through West Orange is Northfield Avenue, but Mount Pleasant Avenue was the best maintained road. In 1806, the state legislature granted a charter to construct a toll road over existing roads from Newark to Morristown. It became known as the Orange Turnpike, and it passed through West Orange over Mount Pleasant Avenue. A tollgate was once located near the current-day intersection of Gregory Avenue. Parts of Mount Pleasant Avenue on the old Orange Turnpike in West Orange still remain under state control today as New Jersey State Highway 10.

West Orange used to have two train stations. It was once possible to catch a train on Main Street with direct passenger service to New York. West Orange also once had cable cars that were pulled from the Orange Valley below through a spectacular 30-foot-deep rock cut to the top of the first mountain.

Upon visiting the Orange Mountains in the 1850s, Llewellyn Haskell decided to make his home on the mountain. He purchased an old farmhouse at Eagle Rock and briefly made his home there. Soon after, he founded Llewellyn Park, and most of his former property remains today as preserved public and private land with an important and common link to the past.

In 1901, Charles E. Duryea, inventor of the gasoline engine in America, came to West Orange to participate in what would become an annual event for several years. The Eagle Rock Hill Climb, as it was known, was a popular challenge for automobiles in the early years. The difficulty of climbing Eagle Rock Avenue in those days lends itself perfectly to this test of mechanical endurance.

Crystal Lake is truly the forgotten era of West Orange's history. During the latter part of the 19th century, it was a popular resort with an amusement park. It was a separate entity but closely associated with the resort then at nearby Eagle Rock. Today only the lake remains, barely noticed and neatly tucked away, awaiting rediscovery at the end of a parking lot.

West Orange will hopefully bring this town into sharp focus by seeing and understanding the visual changes of the last century and allowing a captivating glimpse into the often overlooked history of this community. This book can be a field guide to help discover and explore the forgotten roads of home.

We will never know the excitement of the old amusement park at Crystal Lake on a scorching hot summer afternoon. We will never feel the sensation of a horse and buggy climbing a narrow and dusty Northfield Avenue. And we will never see the sight of an old steam engine chugging into the West Orange train station, but it is nice to know that our grandparents once did.

One

ALONG THE BEATEN PATH
MAIN STREET

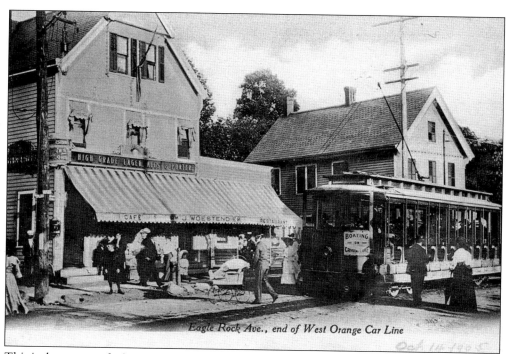

Eagle Rock Ave., end of West Orange Car Line

This is the corner of what is known today as Main Street and Eagle Rock Avenue around 1905. Both buildings shown here are still standing. A brick building sits between them today that was built about 1915. Before this became Main Street, it was considered Eagle Rock Avenue all the way to Washington Street. The trolley in West Orange ended just opposite this corner. This trolley advertises for boating on nearby Crystal Lake.

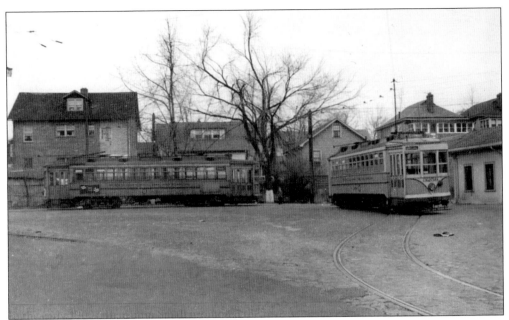

The trolley from Orange ran along Main Street and came to the end of the line in West Orange. It turned around just past the end of Main Street on Mississippi Avenue, pictured here in 1950. These houses are still standing, and this location remains mostly unchanged today. Bus service began in 1929, and it now uses this spot to turn around just like the trolleys of a century ago.

In 1925, this house off Main Street at 14 North Park Drive cost $ 5,600. It was a typical three-bedroom home built in West Orange before the Depression. It was considered modern, with 19 electrical lights and six receptacles. James and Jennie Fagan (grandparents of the author) secured a 6 percent mortgage that was paid off in 1954. In 1928, property taxes were $ 148 a year.

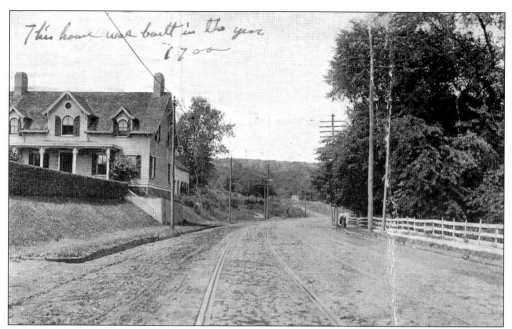

This view from around 1915 is looking north on Main Street from the corner of McKinley Avenue. The house to the left is now gone, but the postcard writer indicated that it was built in 1700. It is possible, since Main Street was along the beaten path of the early settlers. At the end of the fence to the right is the current-day location of the Thomas Edison Middle School.

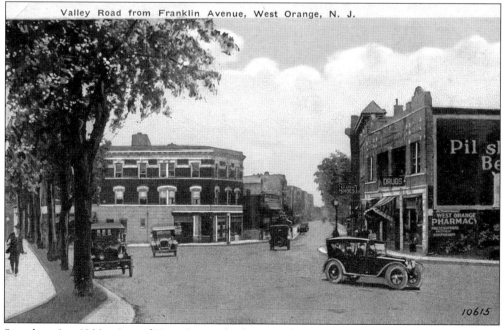

Seen here is a 1920s view of Tory Corner looking south down Main Street (then Valley Road) from the corner of Franklin Avenue. It further illustrates the development of the emerging downtown business district at that time. Washington Street School, which opened in 1895, is directly to the left and just out of view.

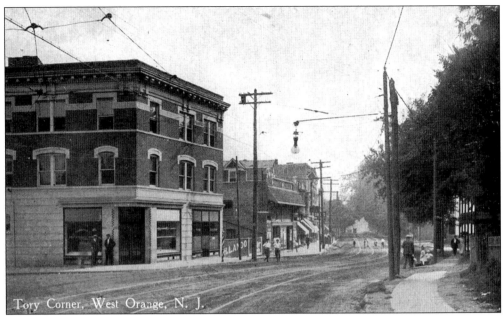

Tory Corner, West Orange, N. J.

The corner of Washington Street and Main Street is known as Tory Corner. It derives its name from several families that lived in this area and remained loyal to the British (known as Tories) during the Revolutionary War. This postcard view from around 1908 is looking south down present-day Main Street from the corner of Washington Street. The building on the left was constructed about 1904 and is still standing.

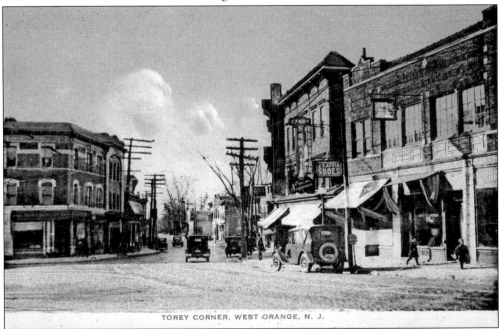

TOREY CORNER, WEST ORANGE, N. J.

Seen here is almost an identical view from about 10 years later. The Tory Corner business district, as it is presently recognized, had begun to take shape. The Rosenbaum building, which is the last one on the right, was built in 1915. The other buildings were all added at about the same time and still remain today as active retail businesses.

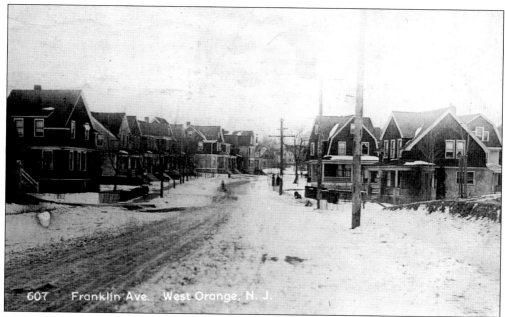

The Franklin Avenue neighborhood is home to Colgate Field, located on the corner of Cherry Street. Seven acres of land were purchased and donated to West Orange by Richard Colgate, a Llewellyn Park resident. The playground was named in his honor and was opened and dedicated in September 1918. Colgate died in 1919 but generously left an endowment fund to defray future maintenance costs of the park.

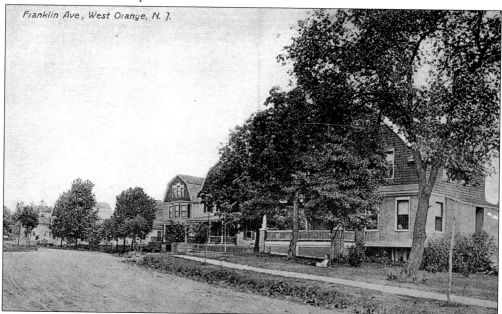

In 1898, Watson Whittlesey developed the area just east of Franklin Avenue then known as Watchung Heights. As early as 1904, today's Franklin Avenue was known as Valley Road. It only connected to current-day Main Street around 1909, at which time it received its current name. It provided residents with a direct link from the Watchung Heights neighborhood to the Tory Corner business district.

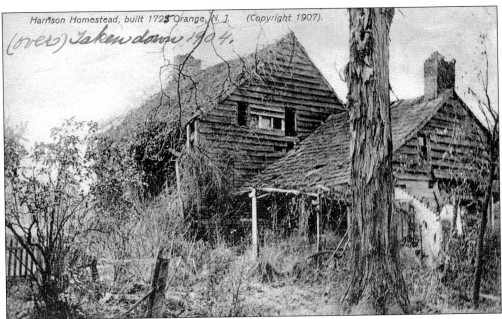

Harrison Homestead, built 1725 Orange, N. J. (Copyright 1907).

(over) Taken down 1904.

One of the earliest homesteads in Tory Corner was built in 1725 by Samuel Harrison. He was the grandson of Richard Harrison, who was one of the original Newark settlers in 1667. Samuel Harrison operated a sawmill along the banks of the Wigwam Brook on what became Washington Street. Nine generations of Harrisons eventually lived here, and the home survived until 1904 when it was torn down.

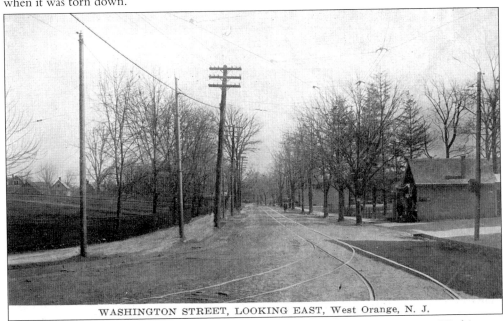

WASHINGTON STREET, LOOKING EAST, West Orange, N. J.

This is a 1930s postcard view of Washington Street. It was named after Gen. George Washington in 1832. Prior to that, it was known as the Swinefield Road. The Harrison homestead was located on this road from 1725 to 1904. It received a brief visit from Washington in 1780 when his troops were passing from Cranetown (now Montclair) to Morristown. They reportedly drew water from Harrison's well for their canteens.

14

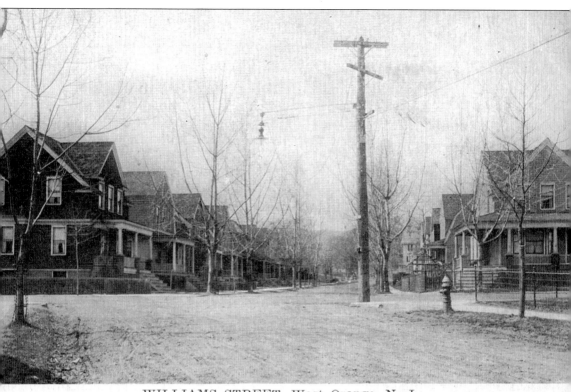

WILLIAMS STREET, West Orange, N. J.

Williams Street in the Tory Corner section of West Orange is mostly unchanged, as seen in this 1930s postcard. In this vicinity lived "Uncle" Anthony Thompson. He lived in a little weather-beaten cottage that he purchased for $800. He was the last known surviving slave in Essex County. He was born into slavery in 1799 in Raritan in Somerset County and freed in 1822. He moved into the small home near Williams Street in 1833. Although a free man, Thompson was in the service of Benjamin Williams at Tory Corner and served five generations of the Williams family. In 1882, he recalled his youth when all the land between the Orange Mountains in West Orange and Newark was a wilderness. Thompson became free at age 34. He lived peacefully and was well liked in his home near Williams Street from 1833 until his death at age 86 on September 16, 1884.

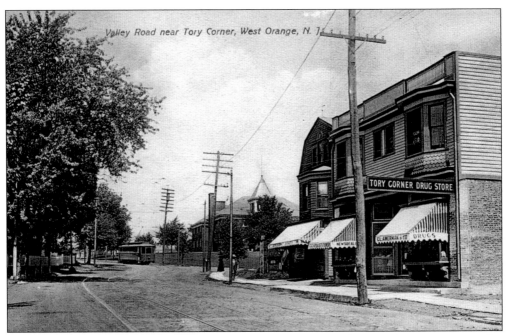

The trolley can be seen rounding the turn at Tory Corner near Washington Street on present-day Main Street about 1903. The clock tower of the Washington Street School is peaking out above the trees just beyond stores to the right. Both of these buildings are still standing today mostly unchanged in appearance but with different retail establishments.

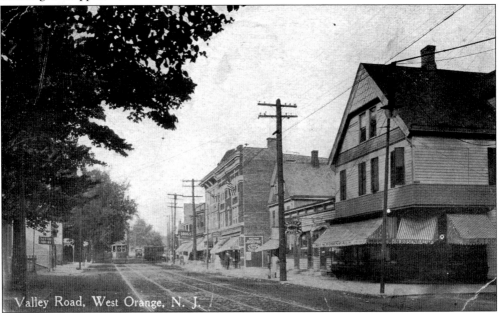

This 1913 view is looking north on present-day Main Street from the corner of Kling Street. The house on the right was then a delicatessen owned by M. Rosenbaum. The building is still standing today. In 1915, he built a brick building just up the street on the corner opposite Washington Street. In the days before modern shopping malls, business districts like Tory Corner were an essential part of most communities.

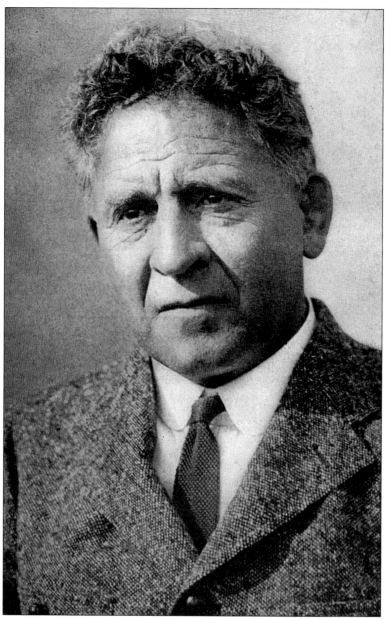

One of West Orange's most forgotten residents is Amos Alonzo Stagg. He was born in the house still standing at 384 Valley Road on August 16, 1862. Stagg attended Orange High School and attended college at Yale. There he played football and was selected to the first all-American team in 1889. He was elected to the College Football Hall of Fame as both a player and a coach in 1951. He also helped develop basketball as a five-player sport and was elected to the Basketball Hall of Fame in 1959. He was a baseball pitcher in college but declined to play professional baseball because they served alcohol at games. He coached college football for more than 60 years. He is considered the grand old man of college football and is largely responsible for helping to develop the modern game. Stagg Field in West Orange was named after him at dedication ceremonies on May 8, 1954. Stagg himself was not able to attend but was represented by his son. Stagg died on March 17, 1965, at age 103 in Stockton, California.

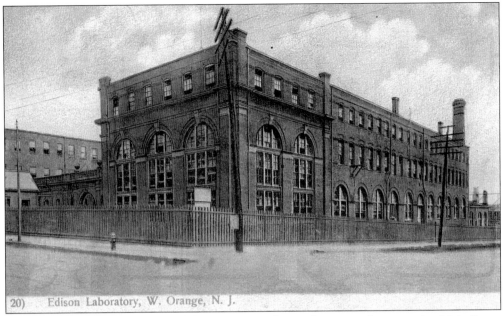

20) Edison Laboratory, W. Orange, N. J.

In 1887, Thomas Edison purchased the property at the north corner of current-day Main Street and Lakeside Avenue, seen here about 1911. He built a three-story brick building 250 feet in length to house his laboratory. Other brick buildings and factories were eventually added. Today this building is part of the Edison National Historic Site operated by the U.S. National Park Service and is currently undergoing restoration.

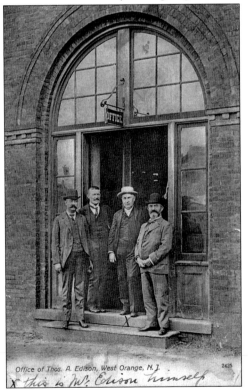

Office of Thos. A. Edison, West Orange, N. J. 2425

X this is Mr Edison himself

This postcard from about 1910 shows Edison standing outside his office in West Orange. The other individuals are not identified. Edison of course is entirely recognizable, but the postcard writer has indicated him with an X. Edison moved his residence to West Orange in 1886 and began construction on his laboratories the following year. He lived and worked in town until his death in 1931.

18

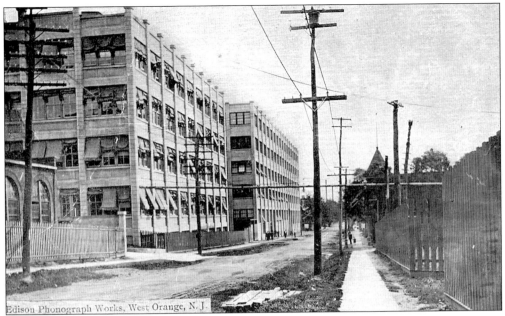

This view from around 1910 is looking south on current-day Main Street from Lakeside Avenue. By this time, Thomas A. Edison Industries in West Orange manufactured many types of special electrical appliances. At one time, the Edison plant in these buildings was one of the world's largest producers of phonographs and phonograph records. The building on the corner is still standing, but several of Edison's factories have since been razed.

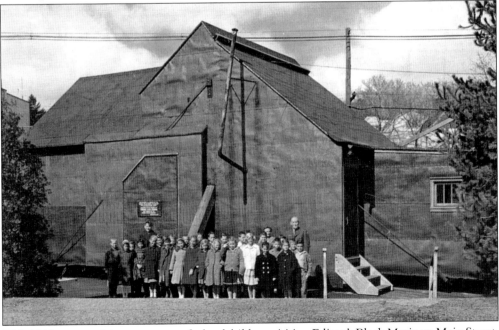

This 1960s postcard shows a group of schoolchildren visiting Edison's Black Maria on Main Street. It was the first motion picture studio in the world when it opened in 1893. It was designed so that the roof could be opened for natural light. The building even rotated to keep pace with the moving sun. It still remains as an active part of the Edison National Historic Site.

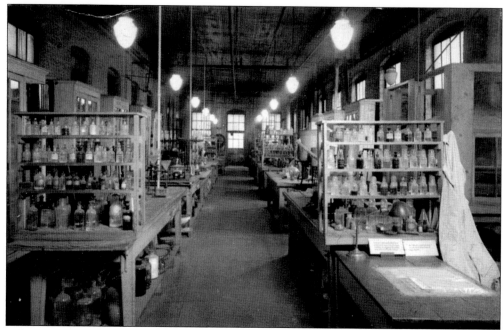

Seen here is an interior view from the 1960s of Thomas Edison's chemical laboratory. At this time, it was still mostly preserved as it was when Edison passed away in 1931. This was a part of the original building erected in 1887. Edison's own worktable and old lab coat are seen.

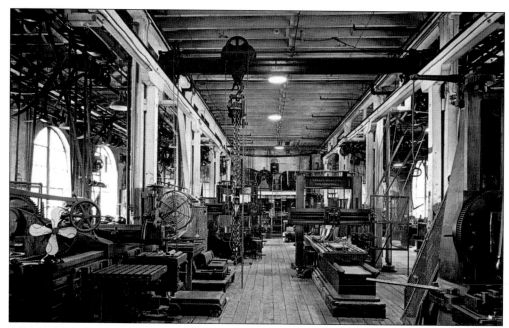

Edison's laboratory also included a first-floor machine shop in building 5. It is seen here in the 1960s and has remained mostly intact from Edison's time. The heavy machinery was powered by drive belts connected to driveshafts that ran the length of the building. He reportedly once boasted that anything from a woman's watch to a locomotive could be produced at his West Orange facility.

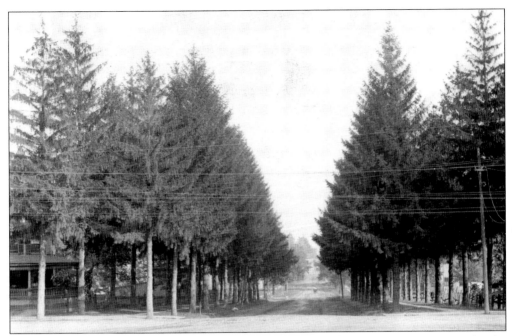

This view from about 1896 is looking east down Park Avenue from Main Street opposite the entrance to Llewellyn Park. The house peeking through the trees to the left is still standing. The Llewellyn Park train station was located just out of view down the end of the tree-lined corridor to the left.

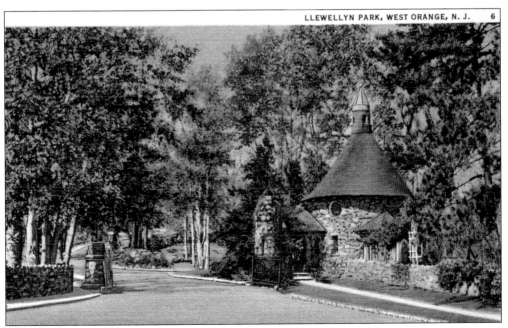

This is a later view from about 1940 of the main entrance to Llewellyn Park on Main Street looking west from Park Avenue. The gatehouse was constructed about 1860 and remains mostly the same today. Other than some changes in the landscape, this scene would still be very recognizable to the park's founder and namesake, Llewellyn Haskell.

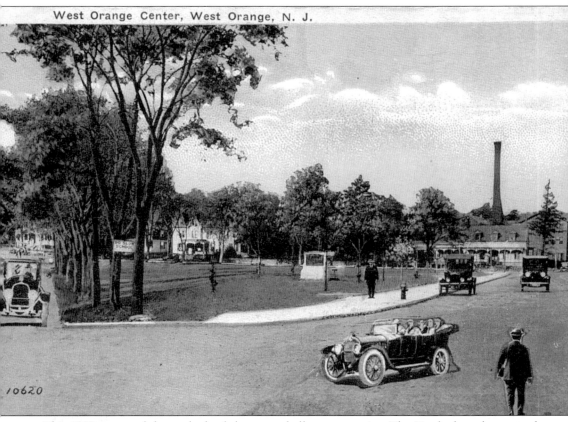

10620

This 1920s postcard shows the land that town hall now occupies. The Hardenburg homestead was previously located here. It was a triangular plot of land formed by Fairmount Avenue (which no longer exists) on the left, present-day Main Street on the right, and Condit Street in the rear (which was actually the beginning of Mount Pleasant Avenue). The land was acquired in 1917 to build a memorial to honor the West Orange boys who lost their lives in World War I. It became known as Memorial Park, and the bronze memorial can be seen in the center of the postcard. Subsequent memorials were added for World War II, Korea, and Vietnam veterans. Town hall is now located here, having opened in 1937. Memorial Park remains in the shadow of town hall and was rededicated by the Veterans of Foreign Wars Post 376 on May 31, 1999. The smokestack to the right was from the Rutan Hat Company that once sat opposite White Street.

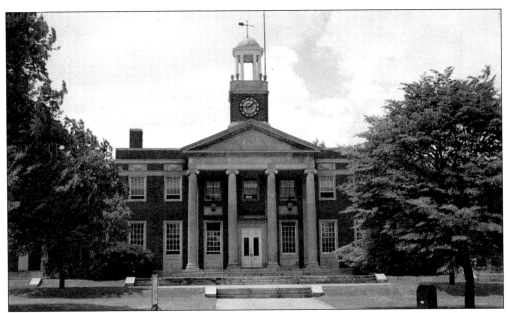

In 1935, ground was broken on the corner of Mount Pleasant Avenue and Main Street for a new municipal building. The cornerstone was laid on October 31, 1936, and the building was put into service with dedication ceremonies on March 11, 1937. The opening coincided with the diamond jubilee of the formation of the township of Fairmount, which became West Orange in 1862. This building is still in use today.

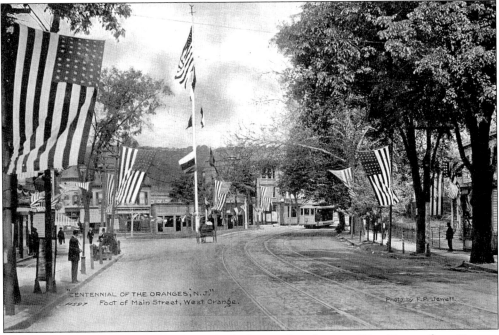

This postcard is looking west in 1907 on Main Street where it enters West Orange from Orange. The flags on the sides of the street are only being displayed for the centennial celebration of the Oranges. The tall white flagpole in the center was the town liberty pole. Here a flag was always on display offering a patriotic greeting for those entering town from Orange.

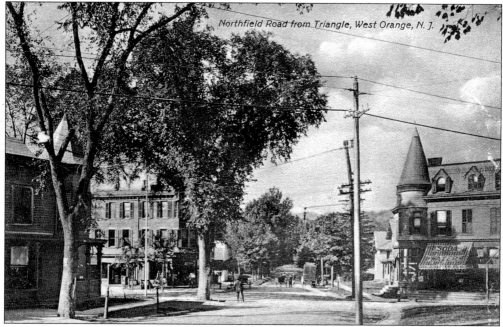

Northfield Road from Triangle, West Orange, N. J.

This postcard from about 1909 is looking up Northfield Road from present-day Main Street. The partial view of the building to the extreme left is the long-gone Coleman's Hotel. The building with the cone-shaped tower to the right was replaced by a modern structure. But just beyond that is the Wheeler Lindsley house on Northfield Road that was West Orange's original town hall.

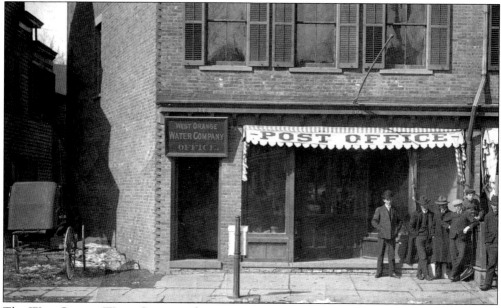

The West Orange Water Company began service in town on June 11, 1892. The water was received from the upper Passaic River. The office seen here about 1904 was located at 323 Valley Road just off Northfield Avenue next to West Orange's first post office. This building is still standing and is also seen in the postcard at the top of the page between the trees to the right.

St. Mark's Place, West Orange, N.J.

This postcard view from about 1901 shows the corner of Northfield Avenue and present-day Main Street. The building to the right with the cone-shaped tower was a meat market and drugstore operated by George J. Geiger. The building is no longer standing but had one of the first public telephone booths in West Orange. The white pole to the left is the town liberty pole.

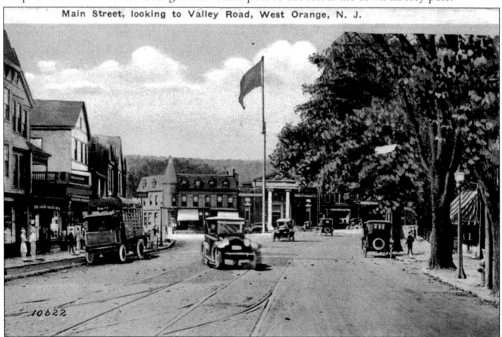

Main Street, looking to Valley Road, West Orange, N. J.

This is what the West Orange town center looked like about 1920. The building with the two white pillars in the center is the First National Bank of West Orange. It was the first bank in town, opening in 1909, and it remains today. The interior of the bank houses three colorful wall murals relating to West Orange history: commemorating Thomas Edison, the cable road, and the Orange Springs Hotel.

25

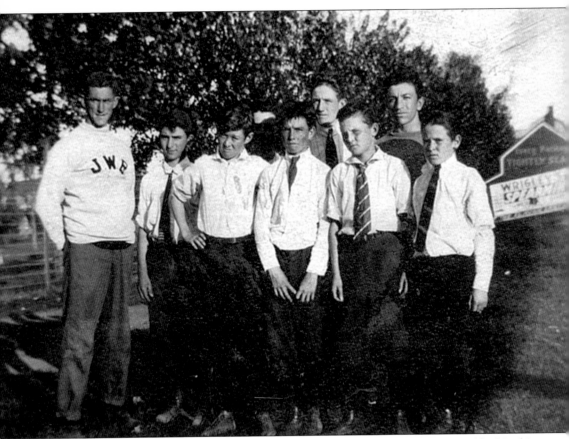

Three acres of land for the first playground in West Orange were donated by Alfred Jenkins of Llewellyn Park. Jenkins Playground was just off the beaten path of Main Street and opened on June 16, 1911. It provided various activities and opportunities for West Orange youngsters. A playground cross-country team is seen here about 1913. Pictured from left to right are (first row) instructor Joe Byrne, George Amabile, Hody Dawson, Bill Leonard, Pete Winkler, and Jim Fagan; (second row) Tom Roach and Rocky Marra. Byrne also taught boxing and was the first supervisor of the West Orange playgrounds beginning in 1913. He went on to serve with the 114th Infantry as a corporal in the army medical corps during World War I. He survived the war and returned home to West Orange but suffered from the effects of being gassed during the war. He passed away on November 19, 1928. In the late 1960s, the construction of Interstate 280 and modern development helped decrease the size of the playground. It survives today with modern playground equipment but only at a fraction of its original size.

Two

THE PLEASANT VALLEY
PLEASANTDALE

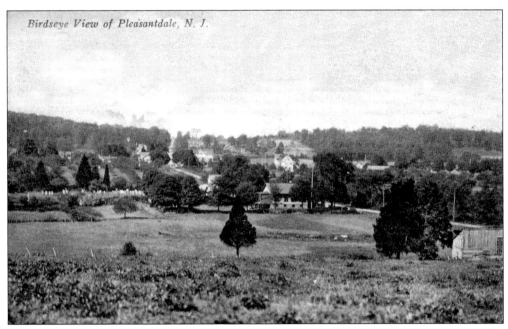

The Pleasant Valley, located between the first and second mountains, became known as Pleasantdale. This view from about 1910 is looking west from the first mountain in the vicinity of what would be current-day Fitzrandoph Road. Headstones from Pleasantdale Cemetery (center left) can be seen in this unobstructed view along the then barren hillside. The cemetery, created around 1840, contains war veterans dating from the War of 1812 through World War II.

Immigrant farmers and stonecutters employed at nearby Shrump's Quarry founded the German Presbyterian Church in May 1878. It was located on the southwest corner of Eagle Rock Avenue and Pleasant Valley Way. A stained-glass window of the original church is seen here peeking out under the tree to the right in this 1906 postcard. Pleasantdale was originally a German immigrant community and remained so into the early 1900s.

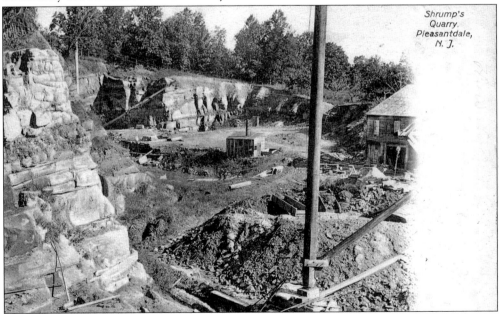

Shrump's Quarry was one of several sandstone quarries in West Orange. In the 1880s, it was a source of employment for German immigrants. It was located on Eagle Rock Avenue just west of current-day Pleasantdale center. It provided the stone for St. Mark's Church in West Orange and Grace Church in Orange. In 1904, workmen uncovered prehistoric fossils at this site that were buried 80 feet under solid rock.

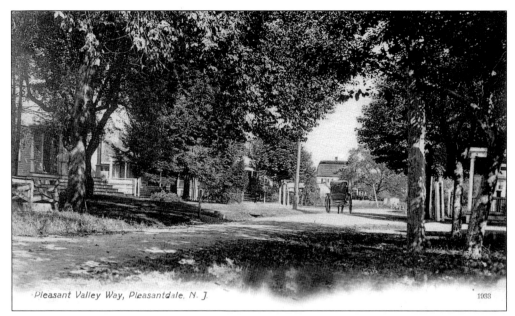

Pleasant Valley Way, Pleasantdale, N. J. 1933

This is a view looking south down Pleasant Valley Way from Pleasantdale center about 1900. As the name suggests, it runs through the pleasant valley between the two mountains. It closely parallels the natural course of the headwaters of the West Branch of the Rahway River, beginning at the outlet of Lake Vincent. Originally it ran only as far south as today's Old Indian Road, then known as Mountain Avenue.

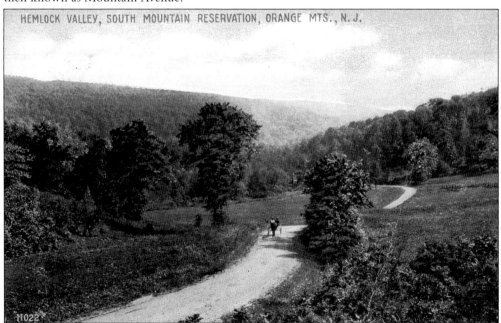

HEMLOCK VALLEY, SOUTH MOUNTAIN RESERVATION, ORANGE MTS., N. J.

Pleasant Valley Way did not extend south to Northfield Avenue until about 1938. It connected to the existing Cherry Lane as it entered the Hemlock Valley of the South Mountain Reservation. Today only a slightly larger double-lane paved road passes over this exact route from West Orange into Millburn. The natural beauty has survived mostly intact and is still recognizable in this postcard view from 100 years ago.

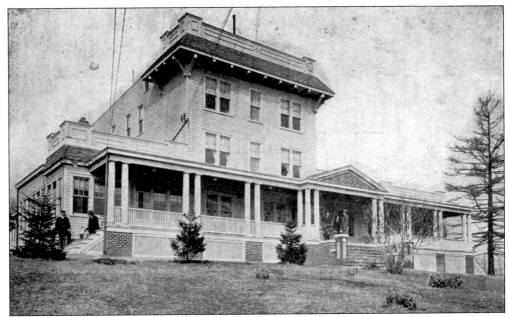

The somewhat rural surroundings north of Pleasantdale center on Pleasant Valley Way proved to be ideal for several hotels and resorts. Two hotels located there were the Idyl Hour Hotel and Klausner's Hotel (seen here). In January 1926, an illegal still was seized during Prohibition in a barn behind the Idyl Hour Hotel. Both hotels are now gone, and Klausner's Hotel last appeared on a 1932 map of West Orange.

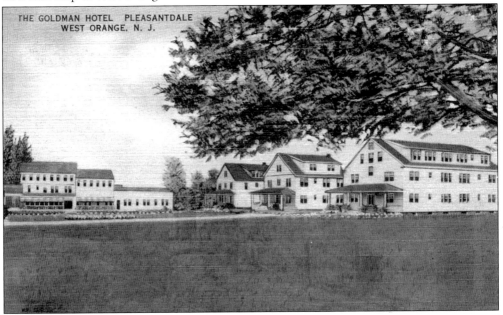

The Goldman Hotel was built in the 1940s on the east side of Pleasant Valley Way north of Pleasantdale center. The hotel was remodeled in the 1960s and became the Town and Campus Hotel, once visited by Pres. Gerald R. Ford. Today this property at 350 Pleasant Valley Way remains an important link to the past as the luxurious Willshire Grand Hotel and upscale Primavera Ristorante.

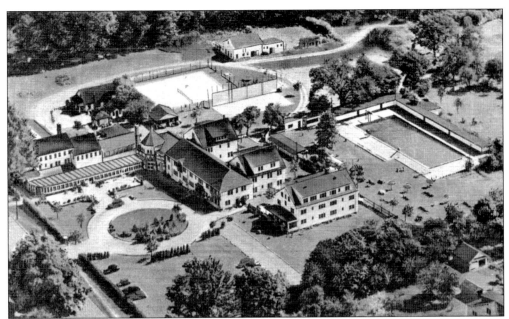

The Goldman Hotel featured an impressive sprawling complex. By the close of the 1950s, urban sprawl was eroding away the rural setting Pleasantdale once offered as a resort destination. In the 1960s, an attempt was made to keep the resort alive by adding a nine-hole golf course across Pleasant Valley Way. By the 1980s, it was no longer profitable and was torn down to build the Woodland Condominiums.

Tennis, Handball & Childrens Playground ◆ THE GOLDMAN HOTEL, PLEASANTDALE. N. J.

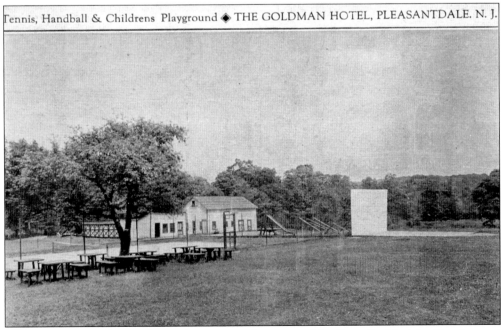

The Goldman Hotel was a destination resort and was one of the first of its kind. It offered several outdoor activities, including a swimming pool, playgrounds, and tennis and handball courts. The Pleasantdale facilities also became a popular place for company picnics and outings in the open, fresh air and peaceful setting of the Orange Mountains.

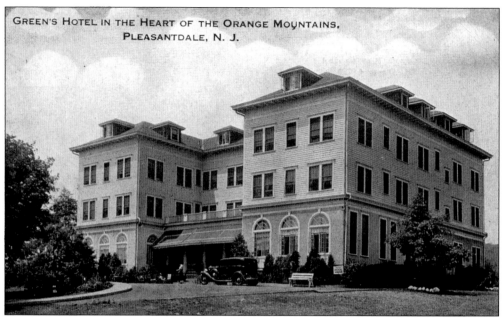

GREEN'S HOTEL IN THE HEART OF THE ORANGE MOUNTAINS,
PLEASANTDALE, N. J.

In 1908, a couple from New York, Louis and Lena Green, purchased an old farmhouse on a 60-acre site in the Pleasantdale section. It grew into the successful commercial venture of Green's Hotel. At one time, it was considered the largest hotel in Essex County. The hotel is still standing on Pleasant Valley Way with a new purpose as the completely renovated Green Hill senior nursing home.

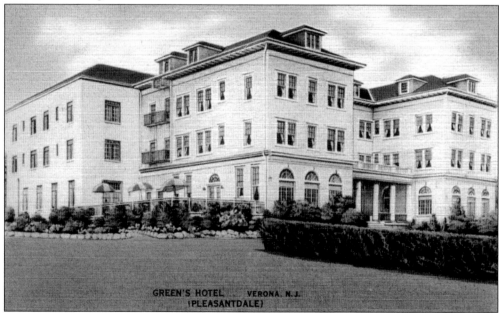

GREEN'S HOTEL VERONA, N. J.
(PLEASANTDALE)

With its close proximity to New York City, the hotel proved to be a popular destination. It provided a pleasant distraction and getaway for city dwellers in the suburban country setting of West Orange. It also featured nightly entertainment and many famous comedians, including Milton Berle, Red Buttons, and Jerry Lewis, who all performed in the cocktail lounge at Green's Hotel.

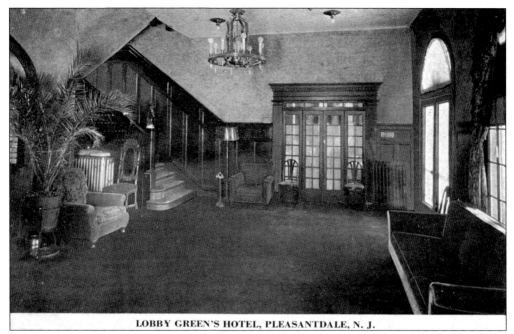

LOBBY GREEN'S HOTEL, PLEASANTDALE, N. J.

The hotel lobby featured luxurious furnishings and was considered modern with air-conditioning. It had accommodations for up to 250 guests. In 1958, the hotel was still in the family and being operated by Irving and Lee Green, the sons of the original owner. On August 10, 1958, a 50th anniversary celebration began with a week of festivities.

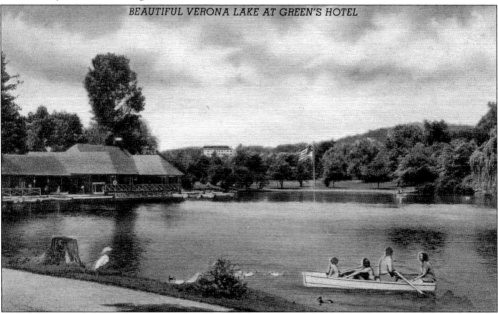

BEAUTIFUL VERONA LAKE AT GREEN'S HOTEL

Perhaps the hotel was visible from Verona Lake, but not as seen in the postcard. Creative license surely was taken to emphasize its close proximity to the popular nearby lake. Green's Hotel could enhance its own venue as a resort by linking itself to boating at Verona Lake. In reality, the lake and hotel were a perfect match but located in separate towns on the adjoining West Orange/Verona border.

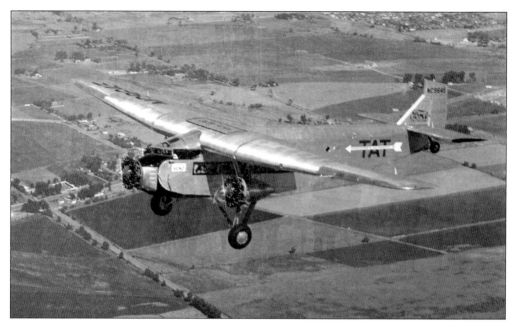

On June 10, 1942, a plane crashed in West Orange at Pleasantdale. It went down in a then vacant field behind Pleasantdale Cemetery. The exact current-day location is the Crestmont Gardens Condominiums on Conforti Avenue. A Ford Trimotor, which is the exact type seen here, left Roosevelt Field in Long Island at 1:10 p.m. and crashed at 1:50 p.m. Pilot Richard Behrens was the only fatality.

The Kessler Institute for Rehabilitation is located on Pleasant Valley Way. It was founded in 1948 as a 16-bed hospital in West Orange for the physically handicapped. It has since grown to become a national and world-renowned leader in comprehensive physical medicine and rehabilitation services. In 2008, a new traffic light was added on Pleasant Valley Way at the entrance to this facility.

Three

THE MOUNTAIN ROADS
NORTHFIELD, MOUNT PLEASANT, AND EAGLE ROCK AVENUES

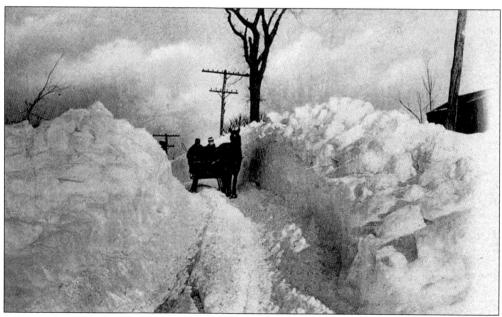

A horse-drawn sled in about 1904 negotiates through the deep snow in the Orange Mountains after a storm. In the days before mechanized equipment for snow removal, passage over mountain roads could be difficult if not impossible. A winter storm or blizzard could simply paralyze any means of travel for days and create hardship. Preparation and self-reliance were essential in a time before modern weather forecasting could provide warnings.

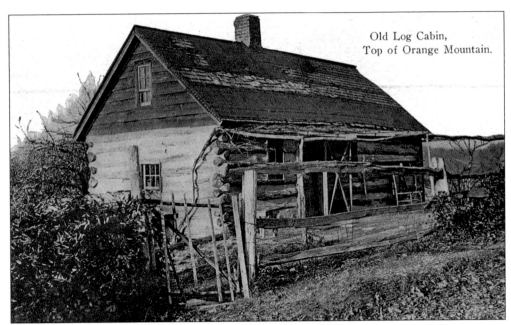

Old Log Cabin,
Top of Orange Mountain.

From the standpoint of topography, the ridges of the first and second mountains of the Watchung Mountain Range encompassing the area of West Orange are known as the Orange Mountains. Log cabins were one of the types of homes built by the first settlers to the area. The abundance of readily available lumber as a resource from the surrounding woodlands made it an easy and obvious choice.

The location of this quaint scene is unknown but is typical of the many crudely built homesteads that dotted the countryside. By the dawn of the 20th century, most of the land in the mountains of West Orange was only sparsely settled. The 1900 census reported that the population of West Orange was a meager 6,889 as compared to the neighboring city of Orange, which had a thriving population of 21,506.

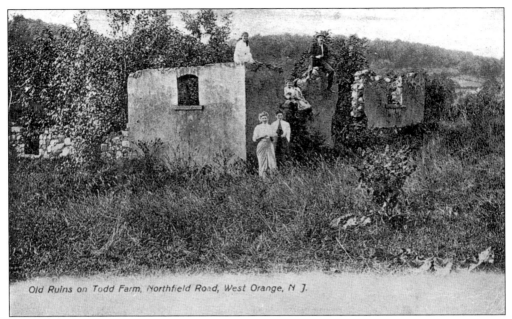

Old Ruins on Todd Farm, Northfield Road, West Orange, N J.

Mostly all the early settlers relied on farming for their livelihood. The soil in the valleys and mountainsides of West Orange was fertile for farming and grazing. Good, natural drainage also fostered agriculture and provided a plentiful water source essential for farming. As the development of the 20th century slowly eroded away the lifestyle of the family farm, the old homesteads became abandoned and fell into ruins.

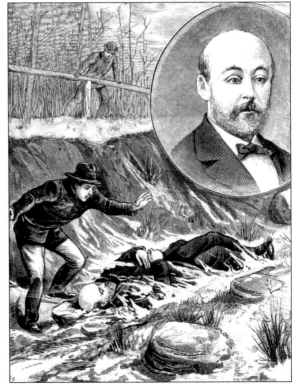

The dangers of the early mountain roads are best illustrated by the death of the famous New York restaurateur Charles Delmonico. He fell to his death in 1884 over the wooden guardrail into a 12-foot-deep gully alongside Northfield Avenue. It occurred about a mile up the road opposite the Collamore residence. Delmonico was discovered by two young boys from Orange who were hunting rabbits on Northfield Avenue.

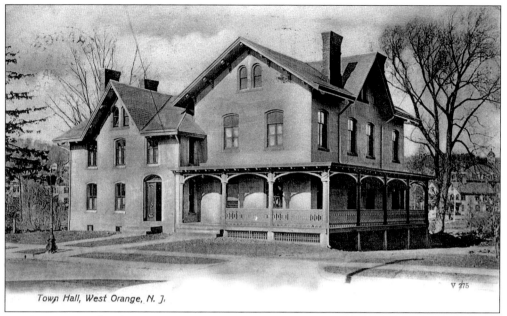

Town Hall, West Orange, N. J,

Fairmount Township became West Orange Township in 1862. It was not until 1905 that the Wheeler Lindsley residence on Northfield Road became the first town hall. By 1915, this building was nearly 100 years old, overcrowded, and crumbling under heavy usage. The municipal government moved into a new building in 1937, and this structure was eventually torn down. A service station now occupies this site.

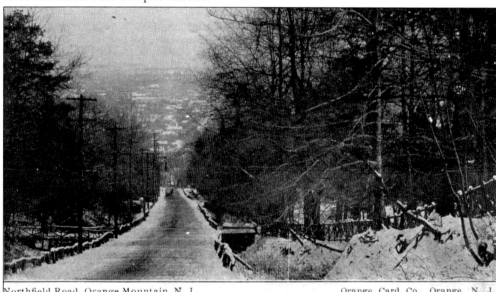

Northfield Road, Orange Mountain, N. J. Orange Card Co., Orange, N. J.

Northfield Road was one of the first roads over the mountain from Newark to points west. It was once used by the New York and Easton stagecoach line. By 1884, the road was macadamized and widened to 25 feet across. Each side had a ravine constructed for drainage and was protected by a wooden guardrail about three feet high. This view from around 1900 is looking east toward Orange.

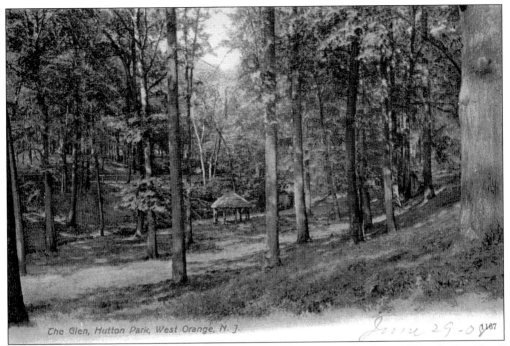

The Glen, Hutton Park, West Orange, N. J.

In 1820, a natural mineral spring was discovered in a ravine on the farm of Joseph Condit off Northfield Avenue. The spring was found to have medicinal properties. This land on the north side of Northfield Avenue with the ponds, streams, and waterfalls would become known as Hutton Park.

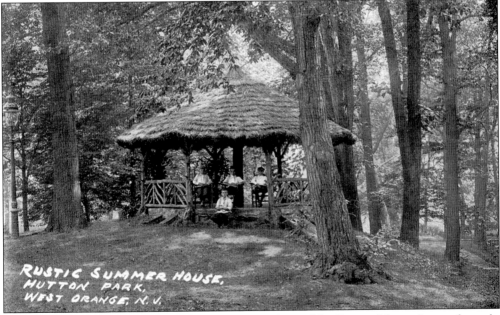

RUSTIC SUMMER HOUSE, HUTTON PARK, WEST ORANGE, N. J.

The healthfulness and natural beauty of the eastern slope of the Orange Mountains was brought to the attention of the outside world by the discovery of the mineral spring. The water at Hutton Park was analyzed by a New York chemist, and news of the discovery spread far and wide. Crowds soon flocked to West Orange to visit the spring in search of its healing qualities.

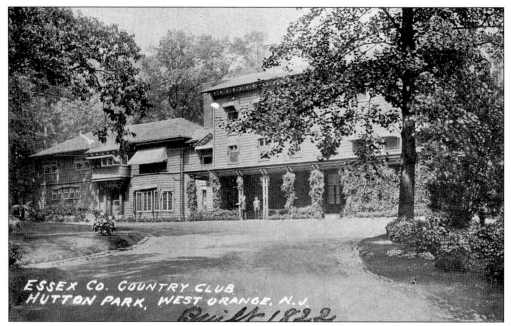

In 1821, 15 acres were purchased at Hutton Park by the Orange Spring Company, and they quickly erected the Orange Spring Hotel in 1822. During the summer of 1823, with an outbreak of cholera in New York City, the Orange Spring Hotel became a popular health resort and destination in West Orange. On October 29, 1824, the Grand Union Ball was held here in honor of the Marquis de Lafayette's visit to America.

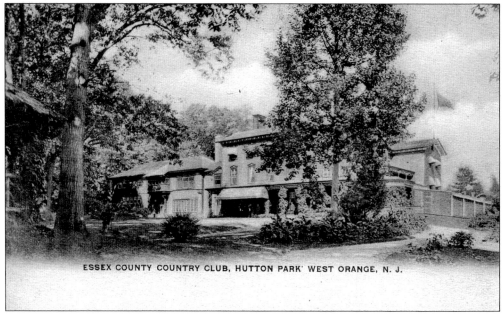

By 1830, the popularity of the spring faded. In 1842, the property was acquired by Andrew Pillot. He purchased additional lands to the west on the mountain. He converted the old hotel to a country home and landscaped the grounds with beautiful gardens and shrubbery. It was at this time that the property actually came to be known as Hutton Park.

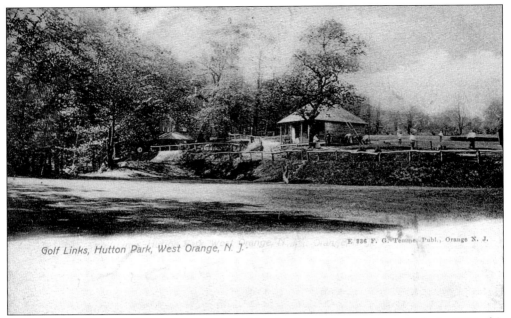

Golf Links, Hutton Park, West Orange, N. J.

In 1887, the Hutton Park property was leased by the Essex County Hunt Club. In 1889, this group and others merged to form the Essex County Country Club, which acquired the hotel and 28 acres. A golf course was built and the old hotel became the clubhouse. The hotel has since been razed and the golf course relocated. The Hutton Lafayette Garden Apartments on Northfield Avenue now occupy this site.

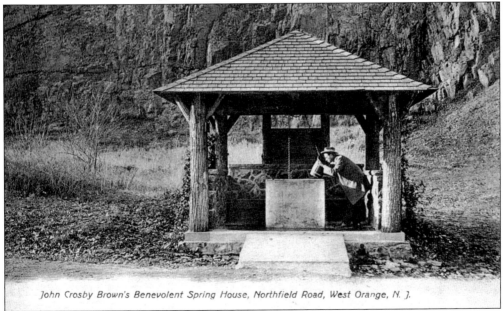

John Crosby Brown's Benevolent Spring House, Northfield Road, West Orange, N. J.

John Crosby Brown was an affluent New York businessman who owned property along the ridge of the first mountain in West Orange. Brown was a benevolent individual who constructed a small shelter over a natural spring on his property on Northfield Avenue. It provided free water for thirsty travelers. The Spottiswoode Quarry operated at this location in the 1880s, and the cliffs seen in the postcard are still visible today.

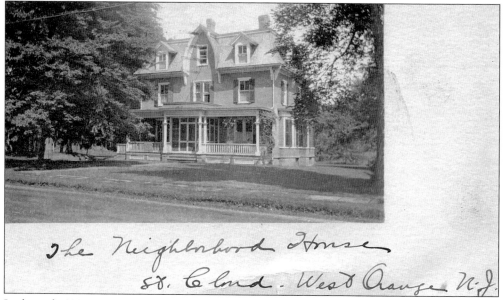

The Neighborhood House
St. Cloud. West Orange N.J.

In the early 1900s, Benjamin Small promoted the real estate development known as St. Cloud on the western slope of the second mountain. The postmark on this postcard is from 1919 and shows the house still standing at 18 Fairview Avenue in the St. Cloud section. This house is typical of the ornate architectural style of many houses that were built in the St. Cloud section.

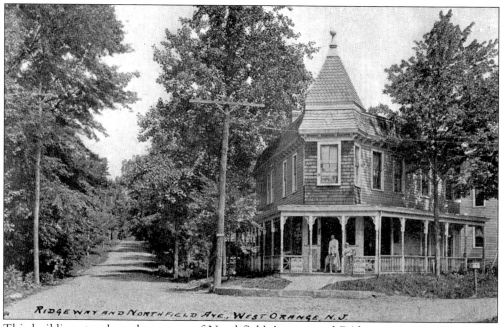

RIDGEWAY AND NORTHFIELD AVE., WEST ORANGE, N.J.

This building stood on the corner of Northfield Avenue and Ridgeway in St. Cloud. The Mountain Railway Company passed here on Northfield Avenue from 1908 to 1914, providing trolley service to the residents of St. Cloud. This building was replaced in 1958 by a professional office building erected by Joseph Falcone, which occupies the site today. The neighboring building barely visible to the extreme right in the postcard is still standing.

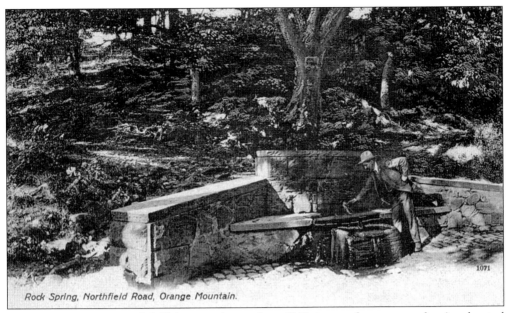

Rock Spring, Northfield Road, Orange Mountain.

The Rock Spring on Northfield Avenue, shown about 1903, is one of many natural springs located in West Orange. More than 100 years later, the spring is still yielding water at this location on Northfield Avenue. Modern equipment of the Rock Spring Water Company now processes and bottles the water commercially. The original stonework remains today and is still recognizable as an old-time West Orange landmark.

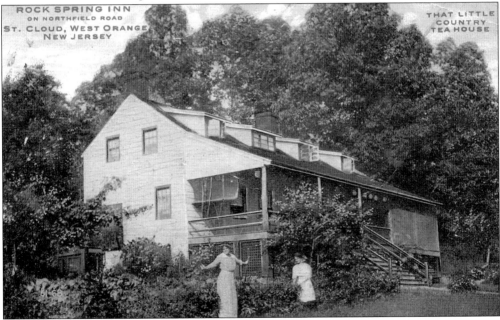

The Rock Spring Inn was neatly tucked into the hillside in the St. Cloud section on Northfield Avenue just west of Walker Road. Its name was derived from the natural spring that was close by on the mountain. It was located at the end of the line for the trolley that once ran on Northfield Avenue from about 1908 to 1914. This location is now occupied by a modern Japanese steakhouse.

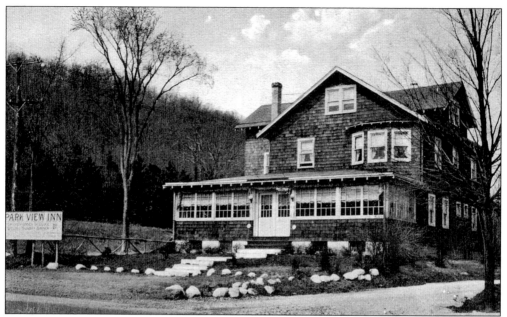

The Park View Inn, seen here about 1940, was located at 615 Northfield Avenue near the intersection with Pleasant Valley Way. It was typical of older homes in West Orange that were converted to restaurants or inns. At the time, its location on Northfield Avenue was considered both scenic and rural. The proprietor was Henry Wernsing, who lived next door at 1490 Pleasant Valley Way.

By the 1960s, the Park View Inn expanded and modernized into a new restaurant named the Westwood. The roofline of the original house was still recognizable. In the 1980s, it was torn down and replaced by Emerson's Restaurant in a new building. Several other restaurants followed, including Doc Callahans and a diner. The new, modern facility of the Atkins Medical Plaza has occupied this site since 2001.

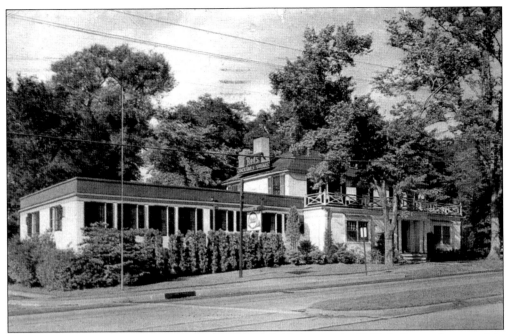

The original Rod's restaurant opened on Northfield Avenue in 1937. It featured a nostalgic 1920s-style setting and decor. Northfield Avenue by this time was already a well-traveled route, but with little traffic, it was considered a peaceful and somewhat rural setting.

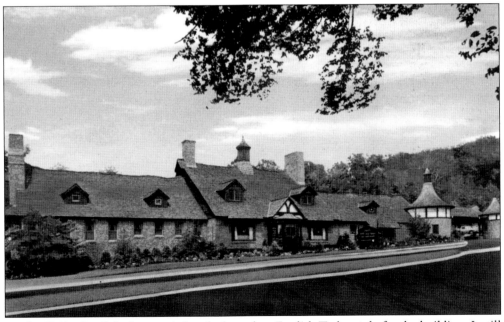

By the 1960s, Rod's had expanded and adopted an English Tudor style for the building. It still maintained its appeal as a nostalgic 1920s roadhouse. It also added an old-style railroad car on the side of the building (out of view) for dining purposes. The business is still on Northfield Avenue in this building, known today as the Essex House Restaurant.

Along the Bank of Orange Reservoir. 128

On October 17, 1882, construction began on a reservoir for the city of Orange within the boundaries of West Orange. A dam was built across the West Branch of the Rahway River south of Northfield Avenue inside the property of the South Mountain Reservation. The total cost of construction including water rights came in under budget at $388,875.44. An 832-foot-long dam was constructed on the south end at an elevation of 142 feet above Cone Street in Orange. A 16-inch pipeline brought water into Orange by gravity flow. A total of 170,811 feet of pipe was used to transport the water from the reservoir throughout the city. The new source of water also provided for 183 street hydrants for fire protection. A daily supply of 1.7 million gallons from West Orange began flowing into Orange on October 1, 1883.

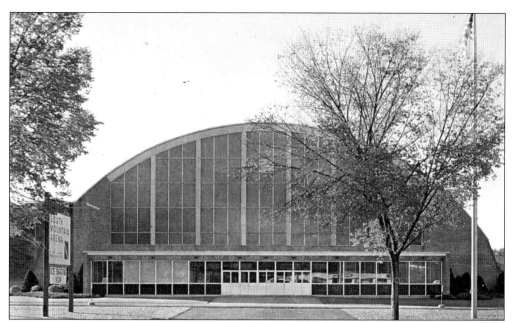

The Essex County Park Commission opened the South Mountain Arena in the fall of 1958. It is located on county-owned land on Northfield Avenue in West Orange. It offered public ice-skating and a venue for ice hockey. Today the arena is still in use but has been expanded and renamed the Richard J. Codey Arena. The original arched facade is still distinguishable in the design of the new building.

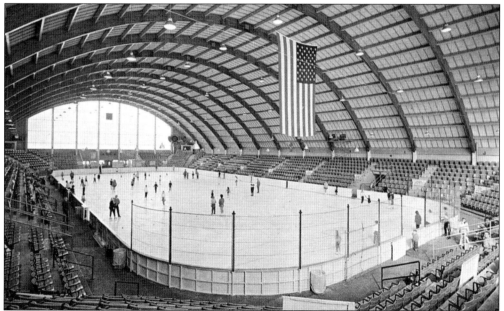

The arena has been used for other events such as flower shows and high school graduation ceremonies. It was the practice home of the New Jersey Devils of the National Hockey League until 2007. The first semiprofessional hockey team to play here was the South Mountain Rockets in the 1960s. In 2008, the arena became home to the New Jersey Rockhoppers of the Eastern Professional Hockey League.

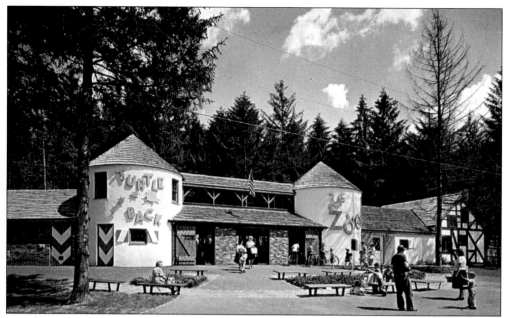

The Essex County Park Commission opened Turtle Back Zoo on June 3, 1963. It is located on a 15.5-acre site in West Orange and owned by the county. The zoo took its name from a rock formation located on the mountainside just east of the zoo. It has since been expanded, and in September 2006, Turtle Back Zoo was granted accreditation by the American Zoo and Aquarium Association.

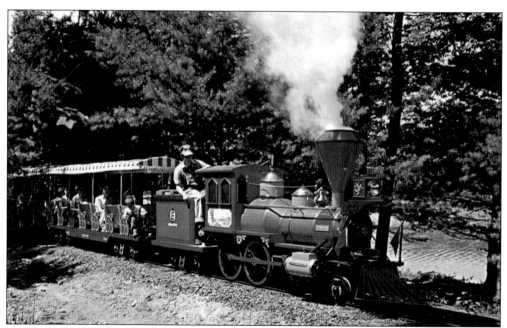

The zoo features a popular miniature train ride, seen here in the 1960s, that still runs today. The ride resembles an 1865 Erie Railroad locomotive. A 60-horsepower water-cooled industrial engine supplies power for the three-ton locomotive. It runs on a mile-long track through a wooded and scenic area alongside the Orange Reservoir.

Mt. Pleasant Ave., West Orange, N. J.

The state legislature granted a charter in 1806 to construct a toll road over existing streets from Newark to Morristown. Known as the Orange Turnpike, it passed through West Orange over Mount Pleasant Avenue. The steeple of St. John's Church can be faintly seen in the distance in this image from around 1904 looking east toward Orange from the intersection of Gregory Avenue. A turnpike tollgate once was located near this intersection.

Before 1900, the roads and streets in town were hardly more than dirt wagon trails. They were either dusty or muddy, and traveling could be difficult. Passage over the mountain roads was certainly lonely and picturesque but at times could even be dangerous. In 1863, the new township committee recognized these shortcomings and created a board of road overseers to raise funds for improvements and maintenance.

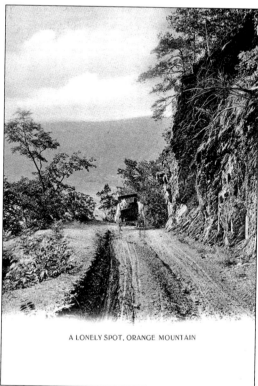

A LONELY SPOT, ORANGE MOUNTAIN

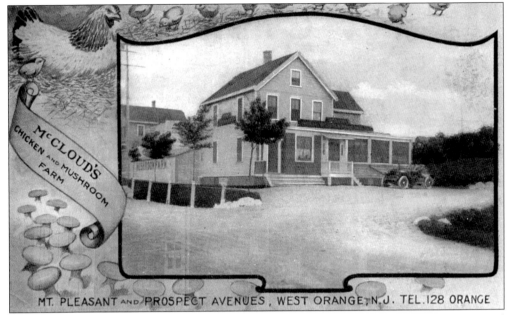

McCloud's Hotel featured a chicken and mushroom farm on the corner of Mount Pleasant and Prospect Avenues. The original house seen here has undergone several additions but is still distinguishable. The neighboring house seen to the left is still standing. The mushroom farm survived as a restaurant into the 1970s. A Japanese steakhouse last occupied the premises but has since closed, leaving this building with an uncertain future.

The Orange Turnpike over Mount Pleasant Avenue was not the oldest road, but it was the best maintained because it was a toll road charted by the state. It remains under state control today as New Jersey State Highway 10. It was one of the earliest routes from Newark dating back to 1700. This view from around 1908 is looking west at the bend in the road above Gregory Avenue.

This postcard view from about 1900 shows the corner of Eagle Rock Avenue and Main Street, which was then part of Eagle Rock Avenue. The building with the awnings to the left is on the corner of Mississippi and Harrison Avenues. In 1916, this building became Fink's Confectionery and Newspaper Store. It remained as such until it was razed in the 1980s. A small gazebo now occupies this site.

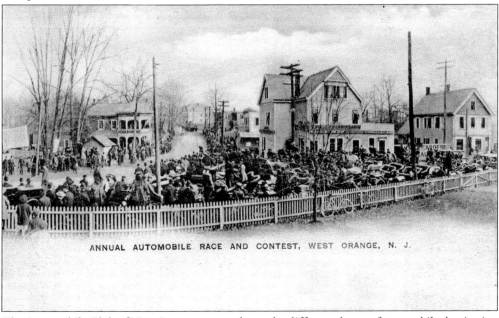

ANNUAL AUTOMOBILE RACE AND CONTEST, WEST ORANGE, N. J.

The Automobile Club of New Jersey sponsored races by different classes of automobiles beginning in November 1901. The races began here at the bottom of Eagle Rock Avenue in West Orange. The course continued up the steep grade and finished near the entrance to the Eagle Rock Reservation. It became an annual event, and races were held each November on Thanksgiving Day from 1901 to 1905.

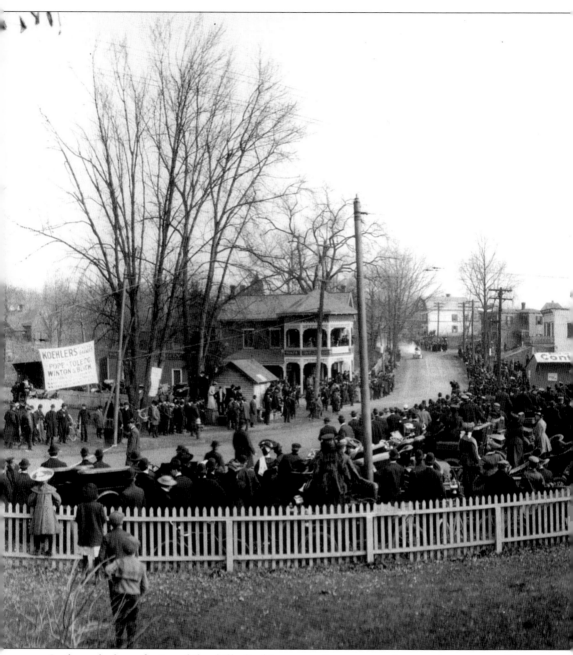

In the early days of automobiles, hill–climbing events became popular as endurance tests for man and machine. The Eagle Rock Hill Climb in 1901 was the first ever in New Jersey and possibly even the United States. Charles E. Duryea of Springfield, Massachusetts, who manufactured the first gasoline automobile in the United States in 1892, participated in the first Eagle Rock Hill Climb. By 1906, town officials determined it to be dangerous, and it was discontinued.

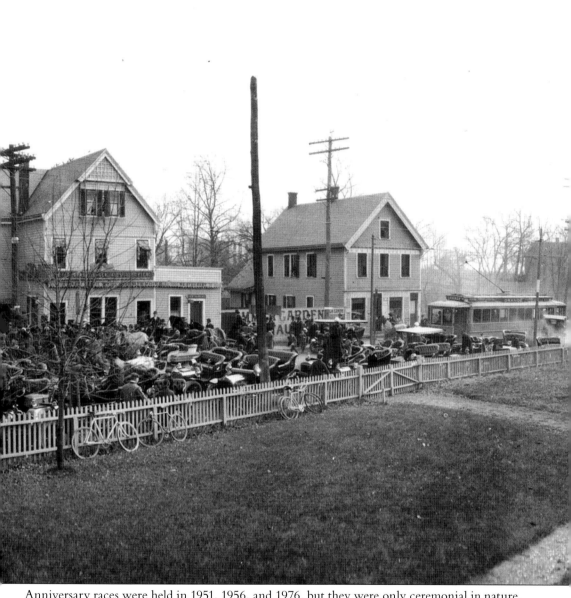

Anniversary races were held in 1951, 1956, and 1976, but they were only ceremonial in nature. In 1951, Duryea's son returned to West Orange to participate in the 50th anniversary of the discontinued event. Pictured above is a surviving photograph of the event taken on November 27, 1903, at the corner of Eagle Rock Avenue and Main Street. It was used to make the postcard on the bottom of page 51.

This postcard from around 1915 shows the present-day corner of Eagle Rock and Harrison Avenues. In the years from 1901 to 1905, this was the starting line of the Eagle Rock Hill Climb. The building on the corner is still standing as the West Orange Pharmacy and remains as a silent witness to this forgotten chapter of West Orange's history.

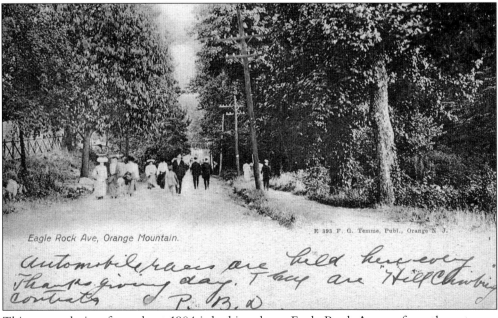

Eagle Rock Ave, Orange Mountain.

E 393 F. G. Temme, Publ., Orange N. J.

This postcard view from about 1904 is looking down Eagle Rock Avenue from the entrance to the Eagle Rock Reservation. It was just beyond this point where the finish line of the Eagle Rock Hill Climb was located from 1901 to 1905. It is interesting to note that the writer of the postcards makes mention of the event: "Automobile races are held here every Thanksgiving Day. They are hill climbing contests."

54

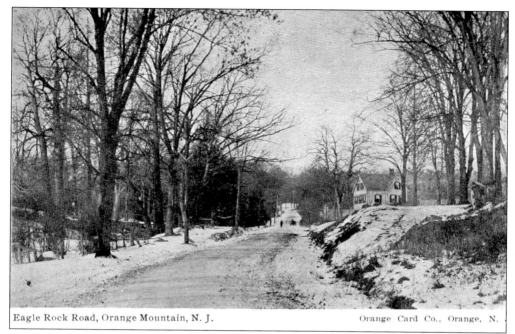

Eagle Rock Road, Orange Mountain, N. J. Orange Card Co., Orange, N.

This postcard view from about 1900 shows just how rural today's busy Eagle Rock Avenue once was. This view is looking west up the hill from the vicinity of where Eagle Rock School was built in 1916. The lone house on the right is on the corner of Calvin Terrace and Eagle Rock Avenue and is still standing today completely surrounded by other homes.

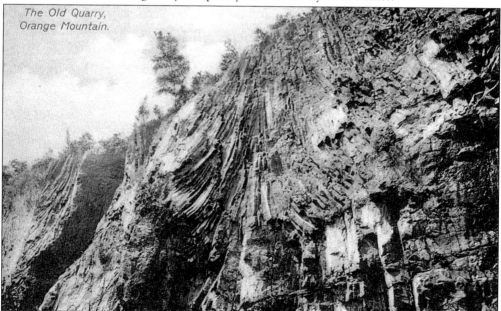

The Old Quarry, Orange Mountain.

By 1868, three traprock quarries were operating in West Orange: the Spottiswoode Quarry on Northfield Avenue, O'Rourke's Quarry on Mount Pleasant Avenue, and the Orange Quarry on Eagle Rock Avenue. The Orange Quarry is seen here around 1900 and was located just south of Eagle Rock. It was the last operating quarry in West Orange into the 1960s. Today the site is occupied by the Crown View Manor luxury condominiums.

Eagle Rock Avenue near Crystal Lake, West Orange, N. J.

This postcard from about 1901 is looking west from the entrance near the Eagle Rock Reservation. At this time, Eagle Rock Avenue was nothing more than a narrow dirt road. After taking a trolley to the base of Eagle Rock, getting to nearby Crystal Lake was done completely on foot by walking down this road.

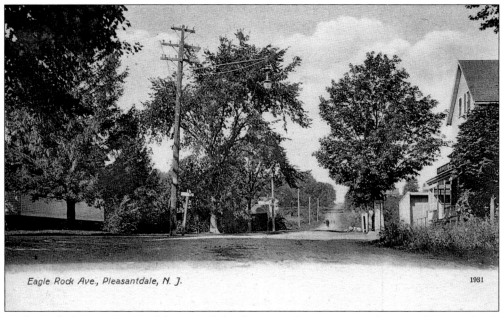

Eagle Rock Ave, Pleasantdale, N. J. 1981

Eagle Rock Avenue is one of three roads leading to points west over the second mountain. It was a well-traveled route originally known as the Swinefield Road beginning at the corner of Washington Street and was named for the farmers who drove their swine to summer pasture over this route. This view about 1900 looks west from current-day Pleasant Valley Way. A general store can be seen on the right.

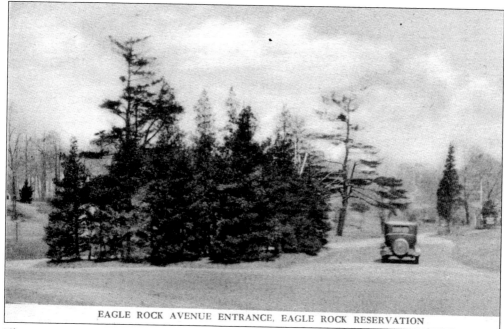

EAGLE ROCK AVENUE ENTRANCE, EAGLE ROCK RESERVATION

The current entrance to the Eagle Rock Reservation in present-day West Orange is not the original. Eagle Rock Avenue once ran directly into the park, as seen here during the 1940s. In the 1950s, this hairpin turn was eliminated, and a new entrance was created on Eagle Rock Avenue about 100 yards to the west that remains today.

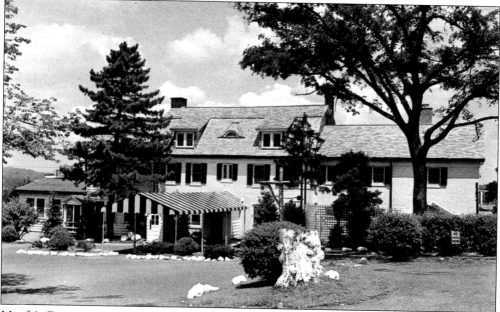

Mayfair Farms, seen here about 1960, is located on Eagle Rock Avenue. It is a 19th-century mansion situated on 14 acres of landscaped lawns and gardens. It originally was a restaurant but is currently used for banquets and affairs. It has been operated by the Horn family since it opened in 1943. The awning over the main entrance was replaced by a larger and more elegant permanent structure.

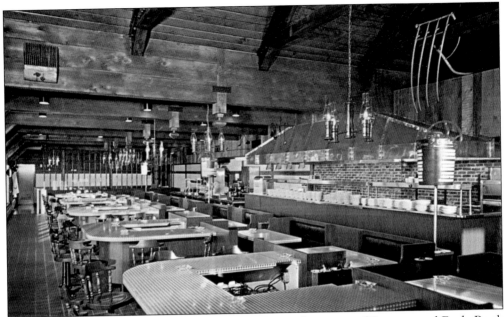

In the 1960s, the Korvette Shopping Plaza was built at the corner of Prospect and Eagle Rock Avenues. It later became Caldor's and is now Kmart, but the original restaurant near the entrance off Eagle Rock Avenue was Costa's Cottage. This 1960s postcard shows the unique and rustic-looking interior of that restaurant. Today this site is the location of the Wendy's fast-food restaurant at the Kmart plaza.

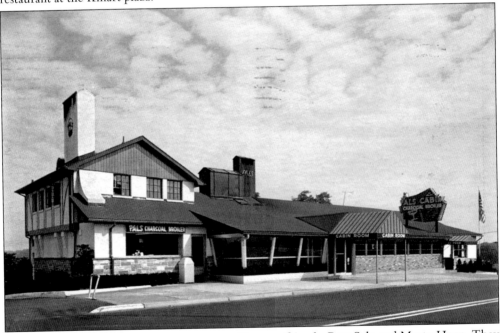

The original Pals Cabin restaurant was started by two friends, Roy Sale and Marty Horn. They opened a small hot dog stand on May 18, 1932, near the intersection of Eagle Rock and Prospect Avenues. The business grew into the Pals Cabin that has become the famous West Orange landmark of today. It has been in business in nearly the same location for over 75 years.

Four

THE ERIE RAILROAD
WATCHUNG/ORANGE BRANCH

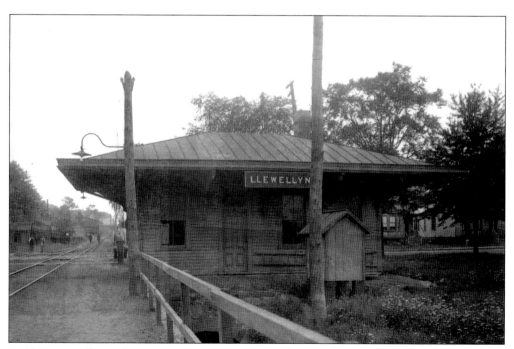

In 1874, a small spur line on the Greenwood Lake Division of the Erie Railroad first entered West Orange. The Watchung Branch, as it was known, began operation on July 3, 1876, from North Newark to Park Avenue in West Orange. The terminus was designated as Llewellyn station because of its close proximity to Llewellyn Park. Llewellyn station is seen here with Park Avenue crossing on the left about 1909.

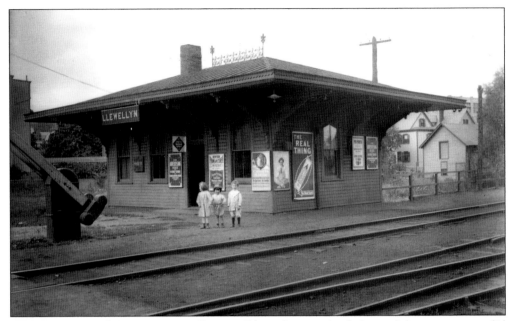

The station on Park Avenue was easily accessible and conveniently located, but commuters did not use the line as anticipated. Usage briefly surged during a railroad strike in 1877 on the nearby Delaware, Lackawanna and Western Railroad line. During that time, the Erie Railroad provided the only means for commuting to New York. However, a lack of patronage caused operations to cease all together on August 31, 1877, leaving the future of the line uncertain.

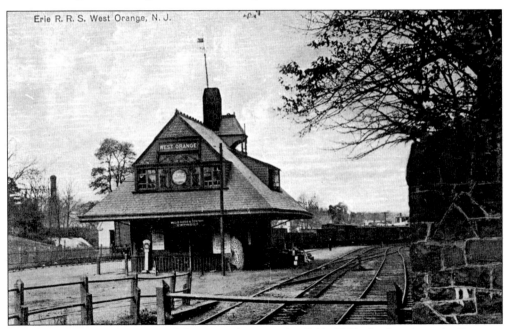

Operations stopped but resumed four years later on April 11, 1881. At that time, the line was extended from Park Avenue to Main Street, and a second station, seen here about 1910, was built alongside St. Mark's Church. The increasing population and growing industry of both West Orange and Orange seemed to hold new promise for the future of rail transportation.

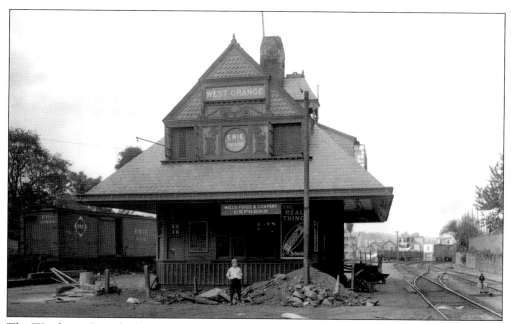

The Watchung Branch changed its name to the Orange Branch even though the Erie Railroad terminated in West Orange. In 1888, the newly named branch first introduced express passenger service from West Orange to New York. In the 1890s, the stationmaster at West Orange was William Marvel. He is credited with inventing the distinguished and recognizable Erie trademark in the diamond-enclosed circle.

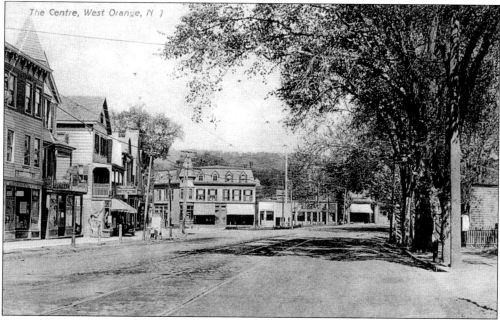

This 1907 scene shows the heart of the downtown business district. The new terminus was located at the town center on the Orange border. Residents now had two stops on the Erie Railroad and their own identity in a new station. The West Orange station is just out of view but located directly to the right. Today the location is used as a parking lot for an appliance store.

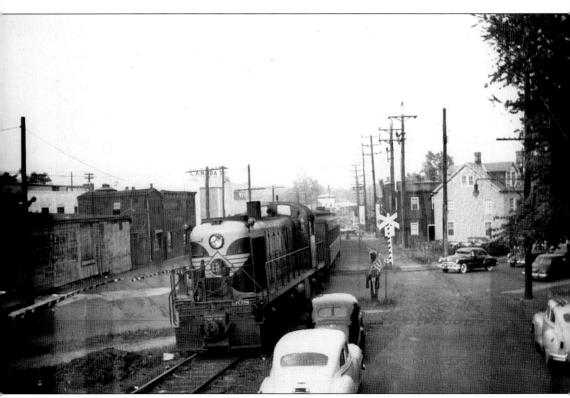

As early as 1900, the Erie Railroad began losing the battle with the competing Lackawanna. The nearby Orange station proved to be more convenient to commuters. By the 1950s, the battle was all but over and it was reported that $125,000 was being lost annually on passenger service. On May 20, 1955, hardly anyone noticed or cared as the last Erie Railroad passenger train left West Orange. Engineer Andrew Donohue and fireman William McMahon pulled the train out of the crumbling West Orange station eight minutes late at 6:58 p.m. Scheduled stops at Llewellyn station and all other stations were eliminated. The train only stopped at Brighton Avenue in East Orange to let off a party of faithful riders. There conductor Abram von Blarcom bid them a final farewell. The train then continued on to Jersey City without fanfare or a formal eulogy to mark more than 80 years of service. The end of an era in West Orange history is seen here as the last passenger train leaves West Orange and crosses Alden Street, Orange, into oblivion.

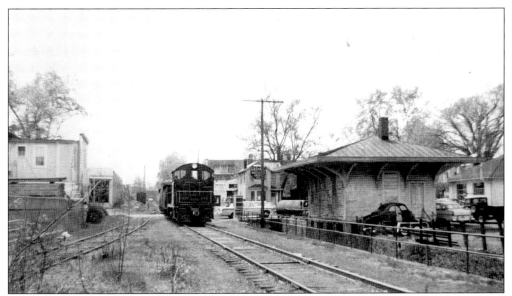

With passenger service terminated, the Erie Railroad sought a new objective to provide freight service to industries along its right-of-way. It was a temporary reprieve to a noble purpose also fast approaching its end of days. This 1963 view shows a deteriorating Llewellyn station at Park Avenue. The Erie Railroad served E. L. Congdon and Sons lumberyard here at this location beginning in 1943. The lumberyard still remains, but the railroad has disappeared.

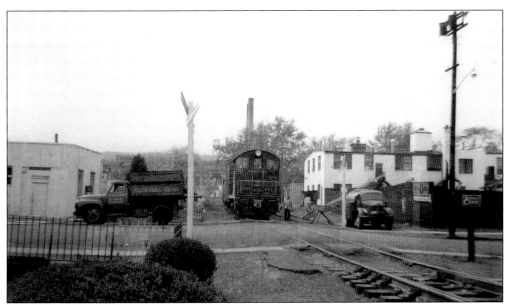

As late as the 1960s, coal was still a necessary commodity as fuel for home heating and industry. The Erie Railroad had served two coal yards in West Orange. The Watchung Coal Company was once located on Main Street directly across from town hall. This one, shown in 1963, was located at the High Street crossing on the West Orange/Orange border. Both have since vanished.

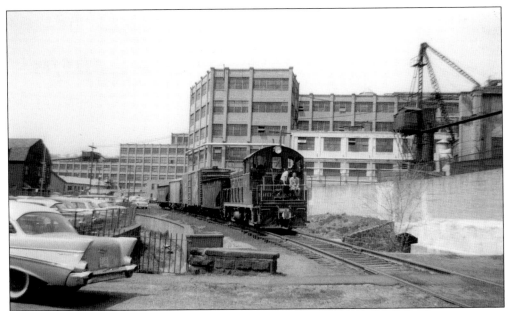

Before the eventual demise of the Erie Railroad, one of its biggest customers was Edison Industries. Here the distinguishable profile of one of the Edison factories can be seen at the High Street crossing in 1963. The factories were once part of Thomas Edison's sprawling industrial complex that was located in West Orange. Some of the buildings survive, but there is no longer any evidence of the Erie's once grand existence.

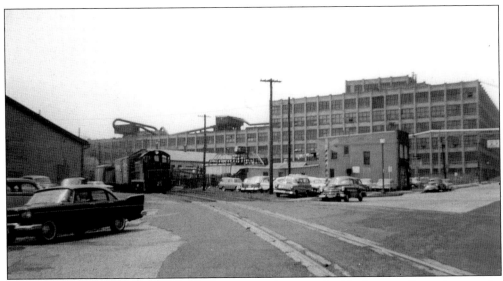

This is another view from 1963 at the Edison complex on Lakeside Avenue. Operations on the Erie Railroad ceased all together in the late 1960s, and both train stations were torn down about 1965. The rails were completely removed by the 1980s. The Erie Railroad played a vital role in the development of West Orange but, like Edison's complex, became extinct. All that remains is a few forgotten and hardly noticeable corridors along the old right-of-way.

Five

CABLE CARS TO TROLLEYS
CABLE ROAD

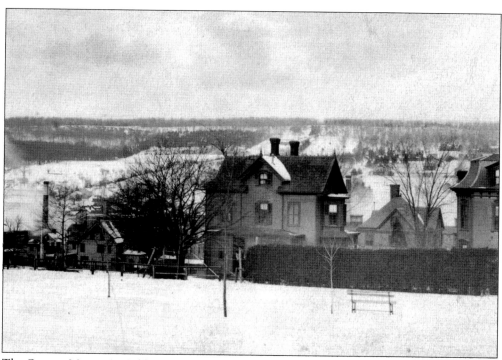

The Orange Mountain Cable Company and affiliated land companies began in 1888 as a business venture to develop the mountain above the Orange Valley. It was headed by George Spottiswoode, a prominent Orange businessman. This 1888 photograph from Scotland Road in Orange shows the clearing of land that began at that time on the mountain for the new cable car route.

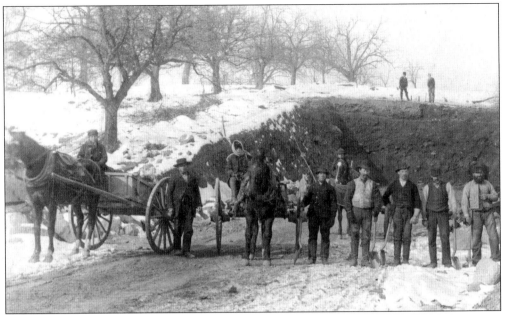

In 1888, construction began at the bottom of the mountain opposite Valley Road at current-day Wheatland Avenue in West Orange. The cable road provided cable car transportation to the homesites sold by the land companies. They ceased to exist once all the land was sold. It was optimistically thought that the cable cars would then serve a perpetual need by providing transportation up the mountain.

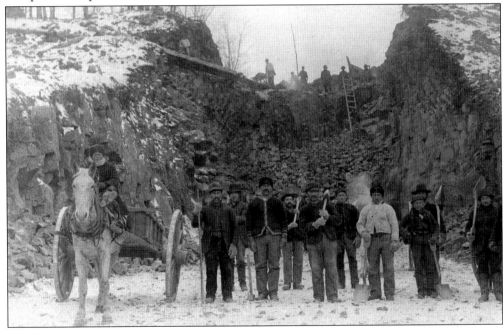

The cable road was a cable railroad named the Orange Mountain Cable Company. It was a straight run of almost a mile with clear line of sight from the summit to the bottom of the mountain. The excavation of a 30-foot-deep rock cut through the mountain was necessary at the summit to reach the western terminus.

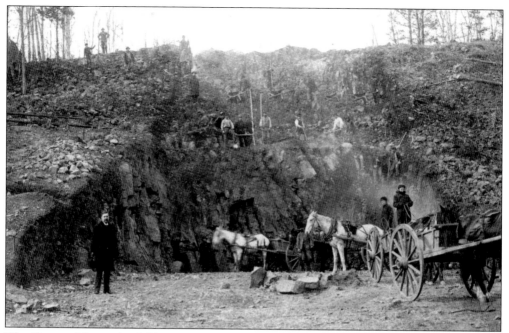

The Orange Mountain Cable Company operated two cable cars raised and lowered by steel cables from a powerhouse constructed on top of the mountain. The excavation of the big rock cut proved to be the biggest challenge. This was the steepest part of the grade where cable cars ascended the summit to the western terminus overlooking the Orange Valley.

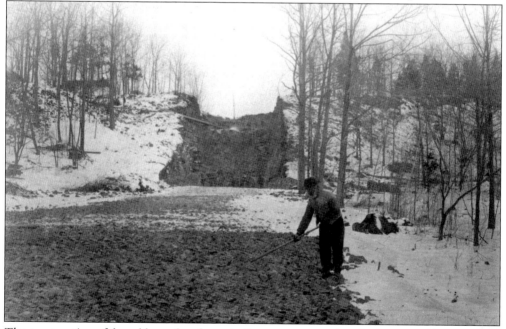

The construction of the cable road took nearly five years to complete. It was no small undertaking that required hard labor and backbreaking work. By the summer of 1892, it was ready to open and provided a much-needed means of transportation from the Orange Valley. This was considered necessary by the developers for land sales in West Orange on the top of the first mountain.

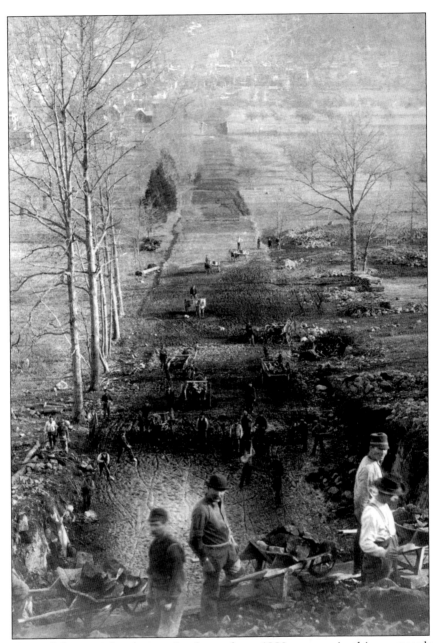

The outline of the route began to take shape about 1889, as seen in this spectacular view looking east from the summit. This is very near the present-day location of the tennis courts at the Rock Spring Country Club. The cable road began on Valley Road in the Orange Valley and ran straight up the then barren hillside. The total distance was to be less than a mile. The only street it crossed was Gregory Avenue, which can be faintly seen running left to right near the top of the postcard. The hardest work was the excavation by hand of a 30-foot-deep rock cut on the eastern slope of the first mountain. Some work was also done with a steam-driven stone drill at the summit level, but it lacked mobility. Here workmen are removing rock by crude wooden wheelbarrows. The excavated rock is being dumped and carted away by horse and buggies waiting below.

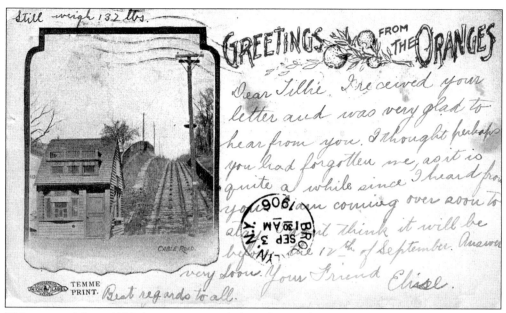

This postcard from 1898 that was not mailed until 1906 shows the small ticket office that was located at Valley Road at the eastern terminus near the Orange border. A similar structure was also built where it crossed Gregory Avenue (then called Wyoming Avenue). The route of the cable road was completely within the boundaries of West Orange but mostly served the residents of the Orange Valley.

This is a view from about 1898 of the powerhouse at the top of the deep rock cut. The operation of both cars was controlled from here. From the second-floor window, the engineer had a clear line of sight down the entire route. He could then be signaled to safely raise and lower both cars as needed. The building to the left is the waiting room.

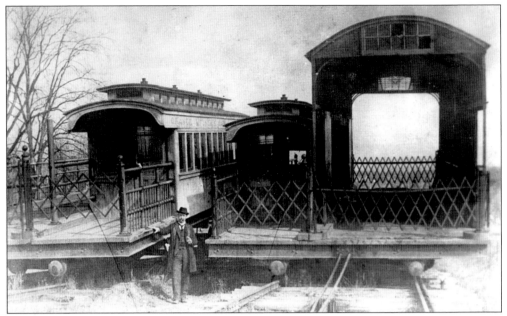

Two tracks each contained a single car. A continuous cable connected both cars and ran up to the powerhouse where it was wound around a drum. When one car was pulled up, the other was automatically lowered, acting as a counterweight. Each car had a large, open platform with a trolley car cabin to the side and could accommodate passengers, bicycles, cargo, and an entire team of horses.

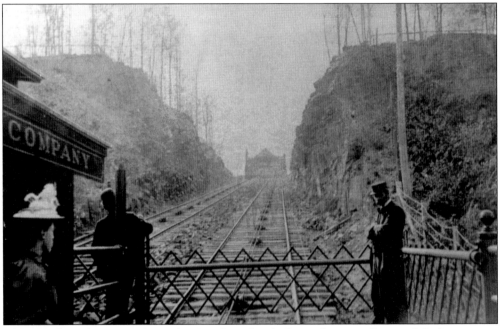

This view from about 1892 shows the view from the platform of an ascending car. It is about to pass through the rock cut en route to the western terminus at the summit. The cables ran on pulleys between the rails of the tracks up to a rotating drum in the powerhouse. The whole operation was controlled by the engineer in the powerhouse and powered by a large steam boiler.

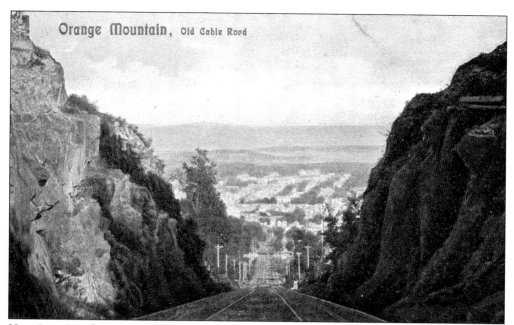

Here is a view from about 1895 looking east down the rock cut to the Orange Valley below. By 1895, the Orange Mountain Cable Company was in financial trouble. Patronage was more a curiosity than a practical means of transportation. This, combined with sluggish land sales, forced it to close. After nearly five years of backbreaking construction and only three short years of operation, the cable road faced an uncertain future.

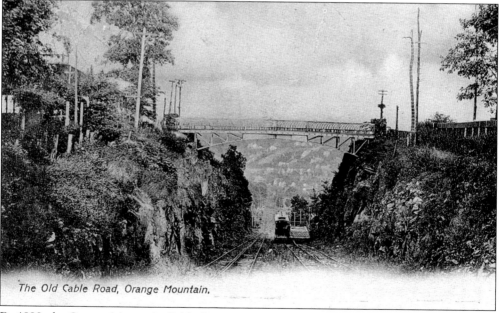

The Old Cable Road, Orange Mountain.

By 1898, the Orange Mountain Cable Company was reorganized under the name of the Orange Mountain Traction Company, and operations resumed. A new park and picnic grounds were built at the top of the mountain, and there was renewed optimism in attracting customers. At this time, an ornamental iron pedestrian bridge was also constructed across the deep rock cut. This bridge became a defining landmark symbol of the cable road.

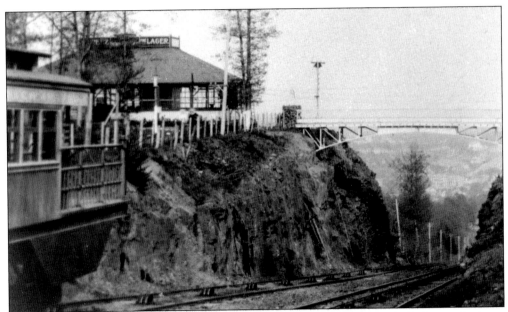

The top of the mountain became the new destination of Highland Park. It featured a large pavilion and dance hall overlooking the rock cut by the iron bridge. It also included several other refreshment stands and a small amusement park. Lodging could be had at D'Alessandro's Hotel directly opposite the eastern terminus at the bottom on Valley Road. Crowds began to swell on weekends, as the park grew in popularity.

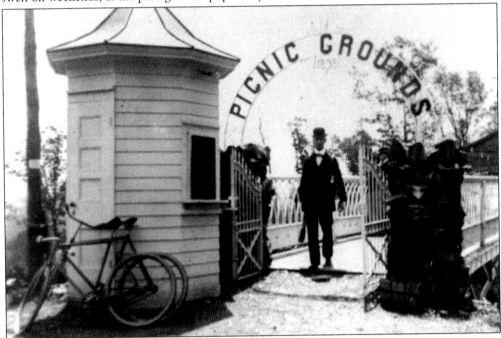

The new park also included picnic grounds. They were accessible by crossing over the iron bridge to the south side of the rock cut. The entrance is seen here in 1898. Crossing the bridge offered a thrill to view the Orange Valley like never seen before. This was truly the golden age of the cable road. Despite its increased popularity, it still had trouble generating a yearly profit.

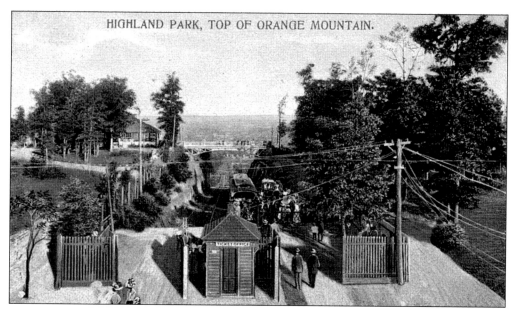

HIGHLAND PARK, TOP OF ORANGE MOUNTAIN.

A new platform was also constructed at the western terminus at the summit in front of the powerhouse. Activity peaked during the summer months and especially on Saturday evenings. It was not unusual to have to wait for two or three trips of the cable car before getting a turn to board. This is the present-day location of the tennis courts at the Rock Spring Country Club.

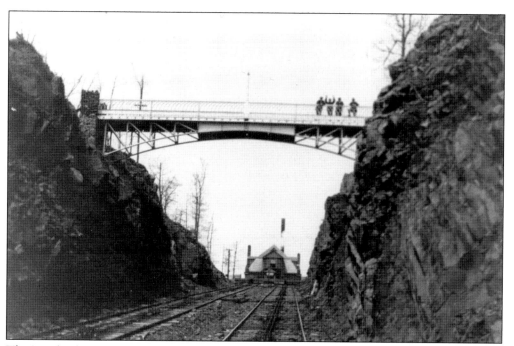

The iron bridge over the rock cut was the centerpiece of the new park. It offered a spectacular view of the Orange Valley below. One summer, entertainment was provided by a daredevil who rode a bicycle and performed on a tightrope across the cut in front of the bridge. There is at least one known death of a girl who was reportedly killed in a fall from the bridge.

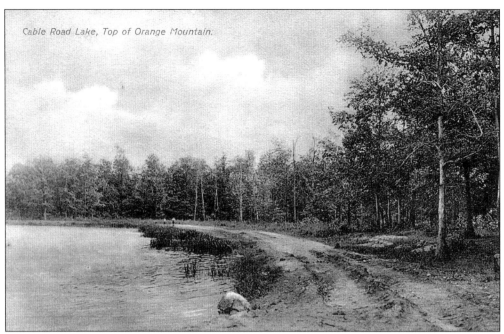

Cable Road Lake, Top of Orange Mountain.

A small natural lake at Highland Park was enlarged and named Cable Lake. It has been often confused with nearby Crystal Lake (see chapter 8), also on top of the first mountain. Today the lake still remains in the shadow of the present-day clubhouse on the grounds of the Rock Spring Country Club.

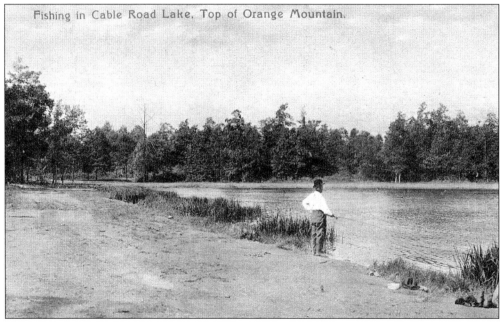

Fishing in Cable Road Lake, Top of Orange Mountain.

The lake provided fishing, but boating and swimming were not permitted. It was also the necessary source of water for the steam boiler in the powerhouse used for the cable road operations. In the winter months, it was possible to ice skate on the lake to the music coming from the nearby dance hall pavilion.

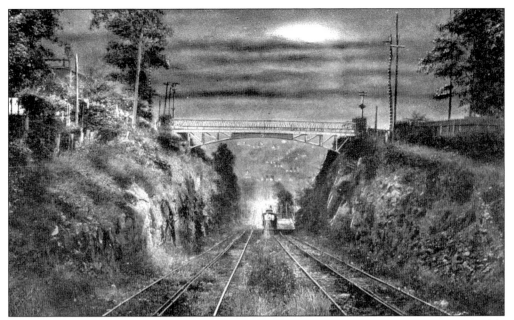

Despite some limited success, financial troubles plagued the cable road. The West Orange cable car era ended for good when service was terminated in 1902. The trolley car had widely become a more practical means for local transportation. Plans were soon considered to replace the cable cars with the more versatile trolley. It made it possible to extend trolley service to points that the cable cars could not reach.

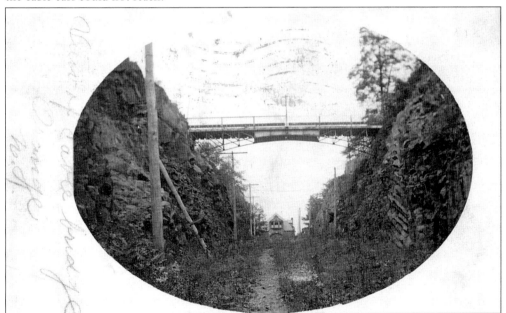

When it closed in 1902, the Orange Mountain Traction Company replaced the cables and rails with a standard-gauge rail for trolleys. They believed that a new improved braking system would allow regular trolleys to climb the steep incline of the old cable road. This eliminated steel cables pulling cars from the powerhouse on top. Trolleys would be powered by their own electric traction motors with new overhead wires.

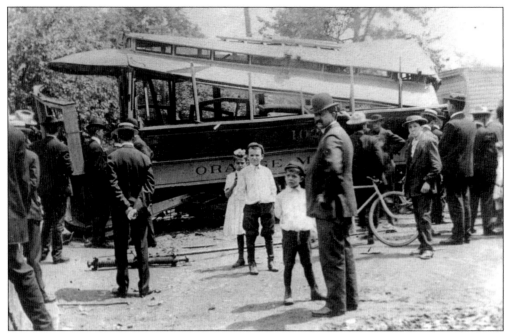

On June 24, 1906, the new rails were laid, and the new trolleys were ready for the inaugural run. Company officials and local dignitaries were to make the first run, after which the line would be opened to the public. Car 102 began the trip and crossed Gregory Avenue without incident. As it entered the steepest part of the grade at the big rock cut, the wheels started to slip.

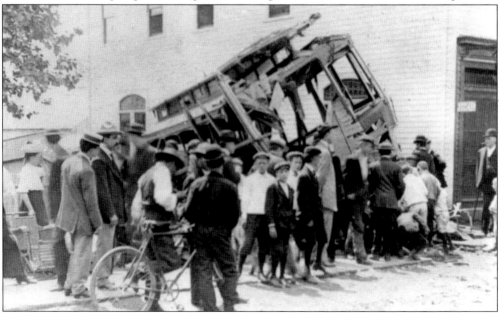

The new brakes failed, and car 102 began rolling back down the hill and out of control. It crashed into car 101 parked at the bottom, hurling it across Valley Road and into an empty lot alongside D'Alessandro's Hotel, seen above. One person was killed, and both cars were completely destroyed. On the first day of operation, it was forced to close. The hotel survives as Quincy's Place restaurant today.

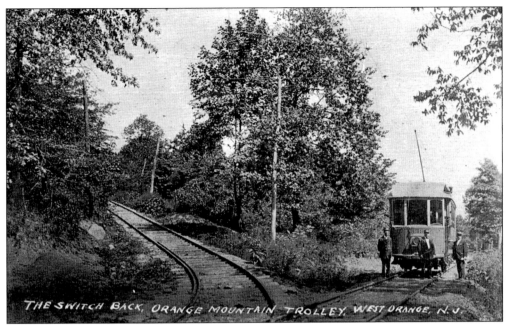

The idea of ascending the steep grade with street trolleys was abandoned. A new company, the Orange Mountain Railway Company, emerged with a different plan for a new, safer zigzag switchback route to climb the mountain. It was a single-track trolley line that used very little of the original cable road route through the deep rock cut. It went into operation in 1908.

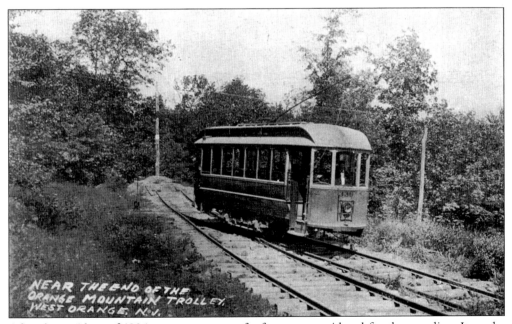

After the accident of 1906, every measure of safety was considered for the new line. It used a winding route up the mountain with a series of three switchbacks. Each had a short counter grade to stop any car that might get out of control. A bank of sand was also used at the end of the track on the switchback, which served as a cushion if needed.

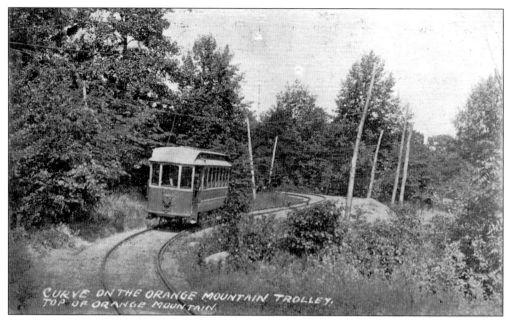

The new line used very little of the original cable road route but crisscrossed it several times. It was deemed unsafe to run it directly through the deep rock cut but skirted it to the south. Once it reached the summit, the line was extended and trolley service was brought onto Northfield Avenue. It ran as far west as the Rock Spring Inn on Northfield Avenue just past Walker Road.

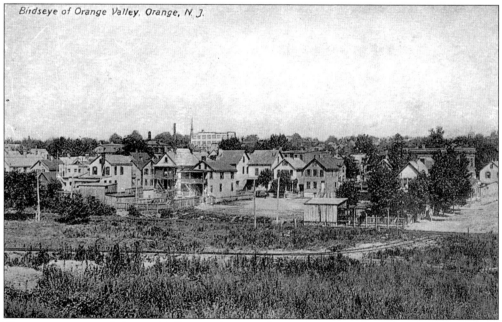

The new route extended across Valley Road just southeast of the original cable road terminus. This view from about 1910 shows the Orange Mountain Railway (foreground) crossing present-day Freeman Place on the Orange border. Here it connected with the South Orange and Montrose Traction Company, which is difficult to see but it runs left to right by the small wooden shelter. West Christopher Street is the dirt road to the right.

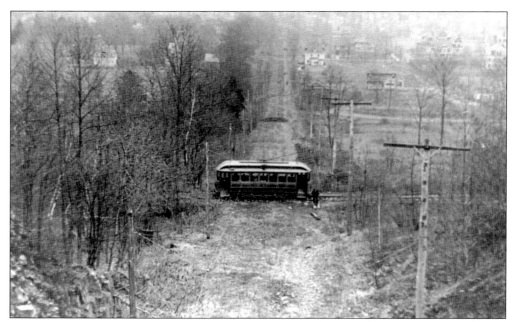

This view shows the trolley crossing the old roadbed of the cable road about 1911 looking east from the iron bridge. The winding route of gentle grades never experienced an accident and proved to be much safer and more reliable. By 1914, the Orange Mountain Railway, like its predecessors, also found itself in financial difficulties. The emerging technology of the automobile and improved roads were proving to be formidable competition.

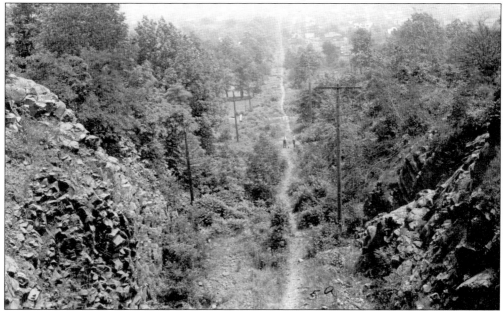

The Orange Mountain Railway was forced to cease operations on June 14, 1914. The rails and overhead wires were soon removed. The switchback route could safely negotiate the steep mountain grades, but financial difficulties proved to be even steeper. The reality of the day was that the end for all trolleys was fast approaching. This is a 1917 view from the iron bridge looking east down the rock cut.

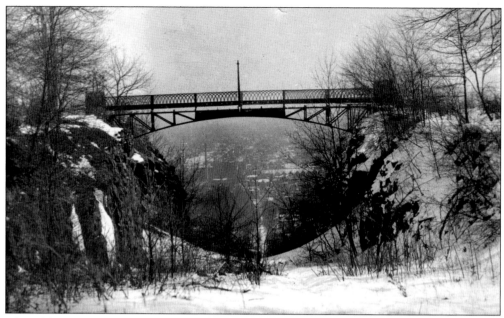

The cable road was abandoned, but the iron bridge of 1898 remained on the mountain as the defining image of its former glory. It survived until around 1949, when it was finally removed. In 1917, Thomas Edison conducted experiments with explosives in the rural setting of the rock cut. He was attempting to develop weapons for the U.S. Navy that could be used on board merchant ships.

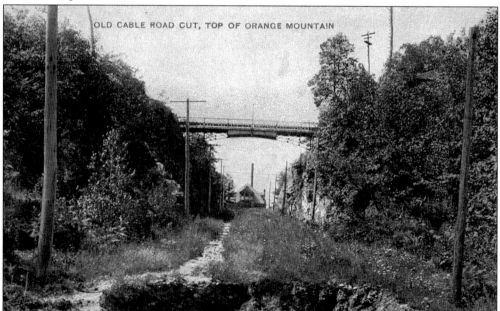

The noble venture began in 1888 but could not gain a foothold into the 20th century. It went from cable cars to trolleys to total extinction in 26 years. The former barren hillside is now completely developed. Years of neglect has left the rock cut recognizable only to the trained eye. It remains hidden away on top of the mountain as enduring testimony to the once majestic cable road.

Six

Laying the Foundation
Praying and Learning

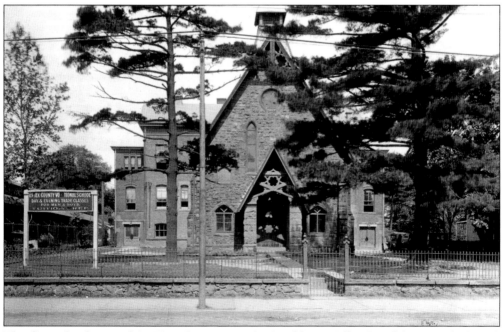

The first school erected in West Orange was St. Mark's on Valley Road (now Main Street) just south of the Llewellyn Park entrance. The school seen here in 1925 was originally built in 1865 and used for all grades until 1912. West Orange's first high school class of nine students graduated from here in 1893. It became a county vocational school in 1914 and was destroyed by fire in 1926.

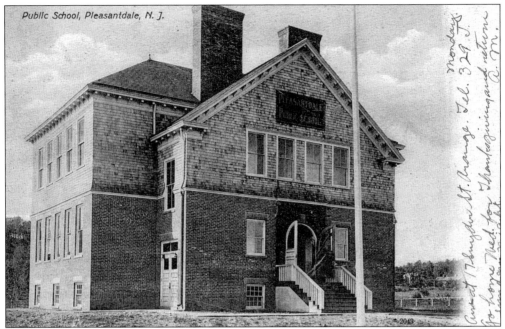

Public School, Pleasantdale, N. J.

In 1870, a wood-frame school was first erected in Pleasantdale. By 1895, it was razed. In 1904, this school was constructed with three classrooms at a cost of $10,000. In 1922, the total enrollment was 108 students. This school is still in use today but has undergone several modern renovations and additions. It still retains the attractive architectural style and charm of the original building.

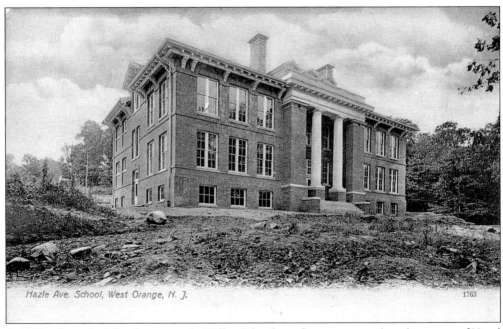

Hazle Ave. School, West Orange, N. J.

In 1878, a frame building known as the Valley School was first constructed on the corner of Hazel Avenue and Valley Road. By 1886, the wooden structure was overcrowded, and the need for a new school became necessary. In 1904, the new Hazel Avenue School opened, and the old Valley School was abandoned. The original building is part of the school today and is still in use.

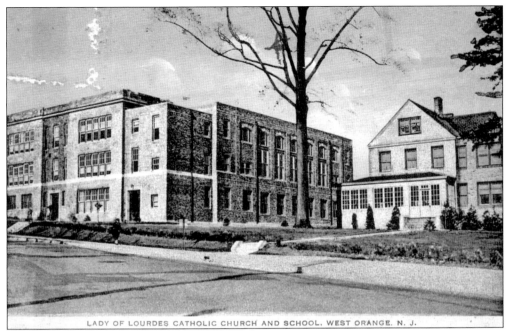

LADY OF LOURDES CATHOLIC CHURCH AND SCHOOL, WEST ORANGE, N. J.

In 1914, Our Lady of Lourdes was established as a new Roman Catholic parish in West Orange. In 1922, three acres were purchased on Eagle Rock Avenue for a new parish home. Construction began there for a school on June 15, 1924. It opened on September 8, 1925, with 297 new pupils. The building remains today, but the school closed on June 16, 2006, after 80 years of service.

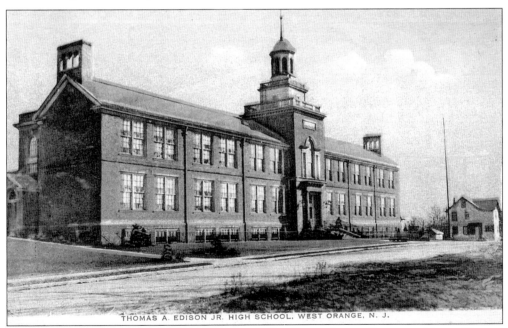

THOMAS A. EDISON JR. HIGH SCHOOL, WEST ORANGE, N. J.

A junior high school bearing the name of one of West Orange's most famous residents, Thomas Edison, was built in 1927. Edison passed away in 1931 but was an invited guest at ceremonies when the school was opened and dedicated. The school has since undergone several additions to accommodate growth, but the original building is still recognizable and in use today.

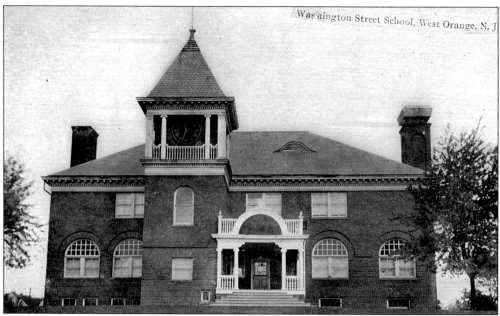

The new Washington Street School honored the name of the country's first president and opened in February 1895. The original brick building was completed for a total cost of about $18,000. Its main feature was an ornamental facade with a tower above the main entrance. Inside the top of the tower, what was then considered the new town clock was housed.

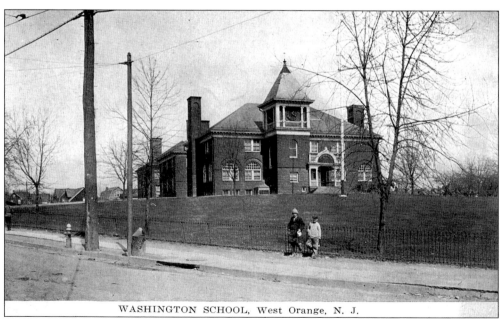

WASHINGTON SCHOOL, West Orange, N. J.

The new school also featured a large auditorium with a capacity of 225 that could be used for community meetings. Subsequent additions in 1899 and 1909 proved necessary to accommodate a growing population. By 1920, enrollment was 811 students, which at the time was the most of any town school. It is still in use today, and its brick exterior remains mostly unchanged as an important West Orange landmark.

84

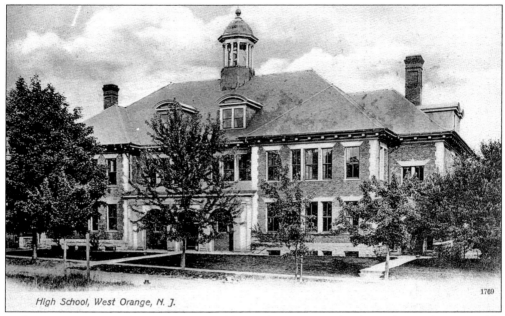

High School, West Orange, N. J.

Before 1890, no schooling was provided beyond grammar school. Students who were able completed their education at Orange High School. The first West Orange high school class graduated in 1893 from St. Mark's school. A new high school building opened in town on Gaston Street in 1898. On July 1, 1901, Vice Pres. Theodore Roosevelt attended a reception here. This building was completely destroyed by fire on February 27, 1913.

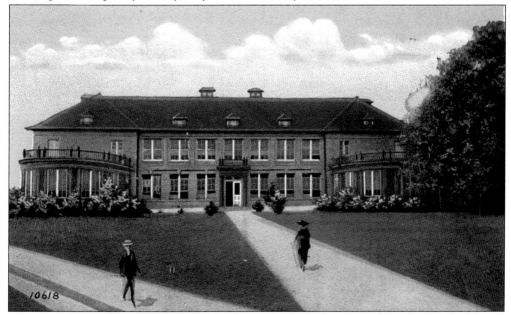

Fairmount School was built in 1912 on Fairmount Avenue, which ran parallel to Gaston Street but no longer exists. It was directly behind the first high school that burned down in 1913. In 1972, Fairmount School moved into a new location, and this building, along with the Gaston Street Junior High School to which it was connected, was demolished. Today the site occupies a senior citizens' housing complex.

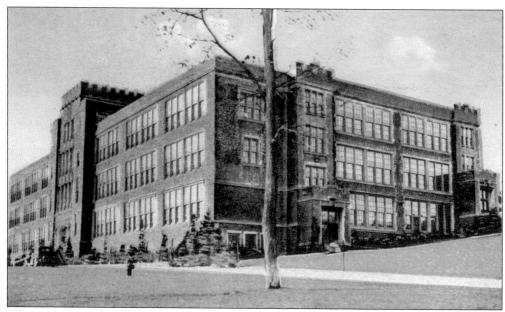

A new West Orange senior high school opened on Northfield Avenue in 1922. It was the only high school in town until 1960 when Mountain High School opened. The Northfield Avenue school closed in 1984. It merged with Mountain High School in the Pleasantdale section to form one West Orange High School, as it currently remains. This building still stands and is in use today as Seton Hall Preparatory School.

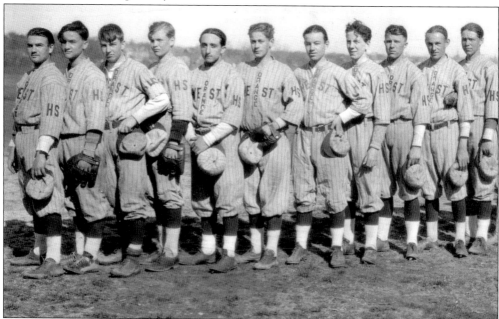

Unidentified members of the West Orange High School baseball team are seen here in 1927. By the mid-1920s, scholastic sports had come to West Orange. Prior to that, participation in sports like baseball was limited to the Jenkins and Colgate Field playgrounds. The cost of equipment sometimes prevented certain youngsters from participating. This was especially true during the Depression years when many families struggled to focus on financial survival.

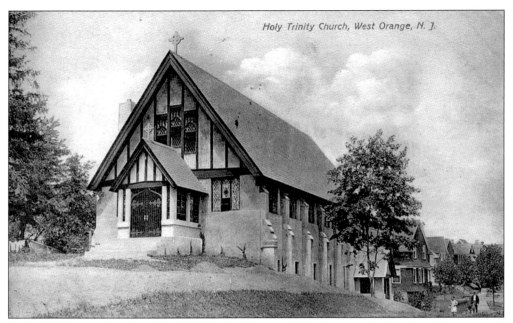

In the 1880s, a series of services held in the home of Mrs. Lyons, who lived on the corner of Mead and Washington Streets, led to the eventual organization of this church on April 2, 1907. Construction began, and the church cornerstone was placed by Bishop Edwin Lines on September 15, 1909. The first services took place here on December 24, 1909. This church and property remain mostly unchanged today.

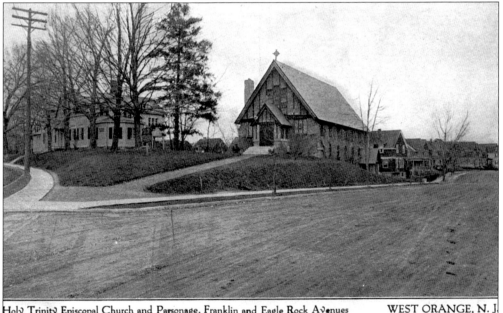

Holy Trinity Episcopal Church and Parsonage, Franklin and Eagle Rock Avenues WEST ORANGE, N. J.

This 1916 postcard lists the location at Franklin and Eagle Rock Avenues. At the time, current-day Main Street was known as Eagle Rock Avenue to Washington Street. This church and parsonage was built on the site of the old Rider homestead, having a frontage of 410 feet on Eagle Rock Avenue (Main Street) and 226 feet on Franklin Avenue.

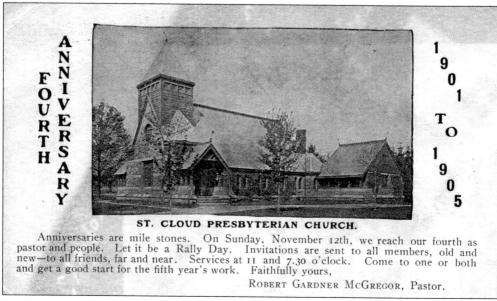

FOURTH ANNIVERSARY

1901 TO 1905

ST. CLOUD PRESBYTERIAN CHURCH.

Anniversaries are mile stones. On Sunday, November 12th, we reach our fourth as pastor and people. Let it be a Rally Day. Invitations are sent to all members, old and new—to all friends, far and near. Services at 11 and 7.30 o'clock. Come to one or both and get a good start for the fifth year's work. Faithfully yours,

ROBERT GARDNER McGREGOR, Pastor.

Services were first held in the newly completed St. Cloud Presbyterian Church on June 10, 1877. In 1880, a chapel was added to the church as a gift of Mrs. John Crosby Brown. West Orange resident George B. McClellan, Civil War general and former New Jersey governor, was a founding member of this church. This 1905 postcard commemorates the fourth anniversary of Robert Gardner McGregor as pastor.

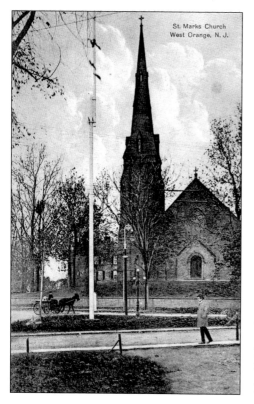

St. Marks Church
West Orange, N. J.

This is the oldest church and perhaps the best recognized landmark in West Orange. It has been overlooking the intersection of Northfield Avenue and Main Street practically unchanged for nearly 180 years. The cornerstone for the church was laid on May 12, 1828, and the first services were held on February 20, 1829. The stone for the building came from Shrump's Quarry in the Pleasantdale section of West Orange.

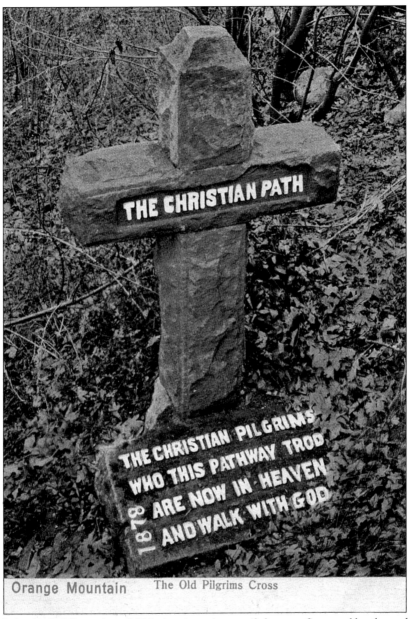

Orange Mountain The Old Pilgrims Cross

The Christian Path followed an old Native American trail that was first used by the early settlers from points west to make their way down the mountain. The name was derived by the numbers of the faithful who had traveled this path to attend church in Orange. Part of the route passed over current-day Old Indian Road in the St. Cloud section. It then connected with Northfield Avenue along the ridge on the mountain paralleling Prospect Avenue. In 1878, John Crosby Brown realized that the former route of the Christian Path passed through his mountaintop property. He then constructed a stone memorial known as the Pilgrim Cross along the ridge to pay tribute to those early settlers who had passed over this path. The historic cross has been moved from its original location along the mountain ridge and survives today. It is now located on the property of the St. Cloud Presbyterian Church. It remains as an often overlooked and important link to West Orange's forgotten history.

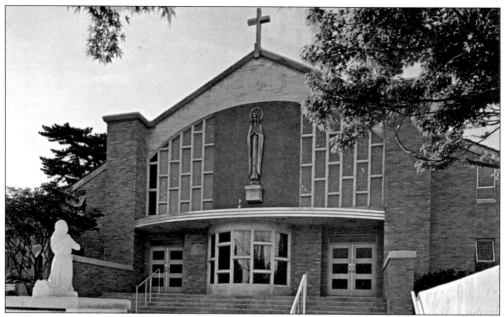

This property on the corner of Eagle Rock Avenue was purchased by Our Lady of Lourdes in 1914. It was a new Catholic parish formed from St. John's Church in Orange in the same year. However, the groundbreaking for construction of this new church did not take place until March 10, 1963. The church was dedicated with the first services held on May 16, 1964, and remains in use today.

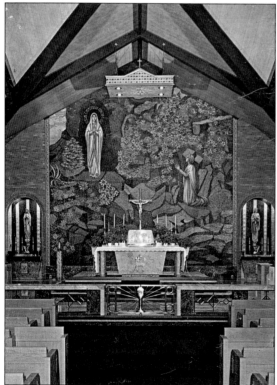

An interior view of the church shows the main altar and the huge imported Italian tile mosaic mural of its namesake, Our Lady of Lourdes. The main altar is constructed of marble also imported from Italy. The massive wooden roof supports are Douglas fir and were transported to West Orange from Portland, Oregon. The church interior remains in its original state and has a seating capacity of 960.

Seven

THE ORANGE MOUNTAIN RESORT
EAGLE ROCK

Eagle Rock Park, Top of Orange Mountain. E 368 F. G. Temme, Publ., Orange N. J.

The open field at the top of Eagle Rock was once a resort with at least six separate buildings as early as 1878. They included a café, a hotel, a cottage, and an inn. By 1900, they were all mostly gone. This postcard view from about 1901 shows the original wooden fence that ran along the drive. This is the present-day location of the September 11 memorial at Eagle Rock.

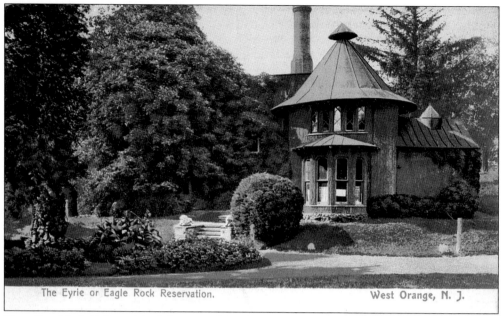

The Eyrie or Eagle Rock Reservation. West Orange, N. J.

Llewellyn Haskell first visited the top of the Orange Mountains in 1853. He so admired the scenic natural beauty of the mountain that he purchased land from Henry Walker. Haskell built his house the Eyrie in 1854. It was the first building at Eagle Rock, seen here around 1905. The Eyrie was only owned by Haskell until 1871 but always retained that name until it was torn down in 1924.

Mountain Path, Eagle Rock

Haskell's love of nature inspired his vision of preserving land for future generations. He purchased much of the mountainside just below Eagle Rock, which became today's Llewellyn Park. Essex County began purchasing the Eagle Rock properties in 1895, including land once owned by Haskell. He died in 1872 and perhaps never realized the impact of his lasting legacy, which separately survives today as both Llewellyn Park and Eagle Rock.

92

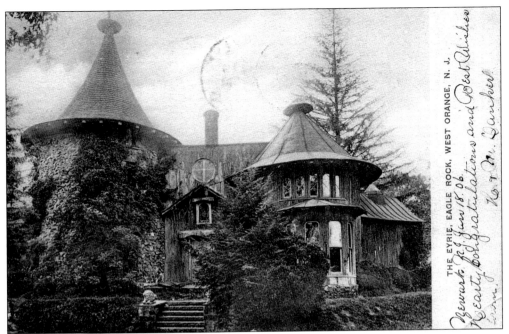

By 1871, Haskell no longer owned the Eyrie, seen here about 1898, or other lands at Eagle Rock. By 1878, a resort known as Eagle Rock Cottage, owned by W. O. Sayles, had developed. The name Eyrie means a nest of a bird of prey. In 1854, Eagle Rock was known as Turk Eagle Rock and was named after the eagles that once nested on the mountaintop.

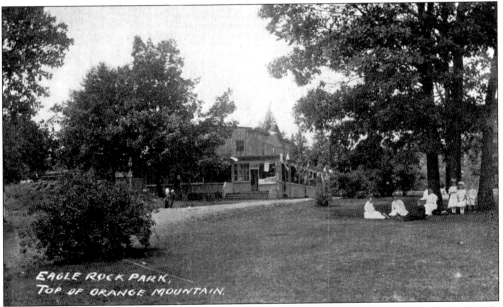

In 1895, the newly formed Essex County Park Commission began purchasing land for Eagle Rock Park with the intended purpose of preserving parkland. The café seen here about 1910 was one of the last privately owned buildings remaining from the 1870s Eagle Rock resort. Surviving veterans of the 13th New Jersey Regiment that fought during the Civil War held their reunion here in 1897. The building was razed around 1911.

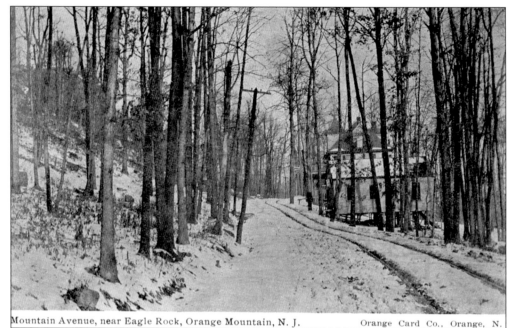

Mountain Avenue, near Eagle Rock, Orange Mountain, N. J. Orange Card Co., Orange, N.

A trolley line opened in 1894 to the foot of Eagle Rock. It increased access for the weekend crowds traveling to both Eagle Rock and nearby Crystal Lake. This 1903 postcard shows the trolley line along Mountain Avenue in West Orange just below Eagle Rock. The City View Hotel is the building to the right and was located at the end of the line for the Eagle Rock trolley.

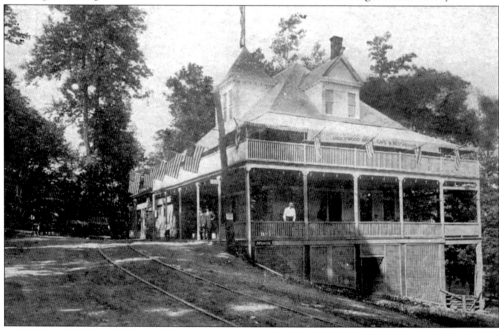

This 1901 postcard shows the City View Hotel on Mountain Avenue, which was owned by George Underwood and his brother at the time. It featured both a café and a restaurant. In later years, John Cox was the proprietor, at which time it was know as Cox's Hotel. The hotel is no longer standing but was located on the present-day corner of Mountain Avenue and Murray Street.

94

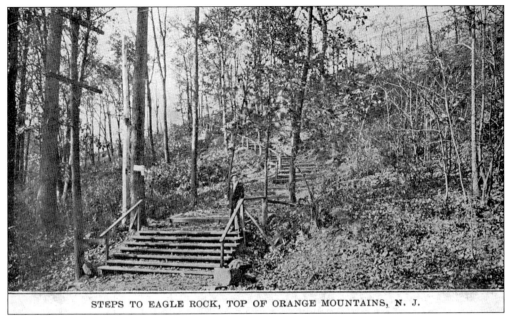

STEPS TO EAGLE ROCK, TOP OF ORANGE MOUNTAINS, N. J.

The trolley line terminated at the City View Hotel just below Eagle Rock. From here, the journey to Eagle Rock had to continue by foot up the 100 steps, which were located along the hillside on Mountain Avenue just across from the hotel. They are seen here about 1910 but no longer remain, although the trained eye can still detect the old grade now badly overgrow with brush.

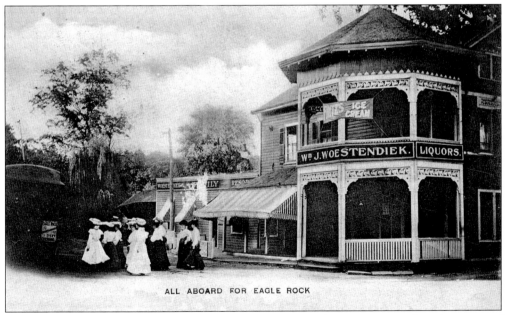

ALL ABOARD FOR EAGLE ROCK

William Woestendiek's confectionery store, seen here around 1905, once stood on the corner of Mississippi and Harrison Avenues and was a stop for the Eagle Rock trolley. The trolley ran up Washington, High, and Chestnut Streets. It crossed over to Cherry Street along Oxford Place and continued to Harrison Avenue where it turned before coming to this corner.

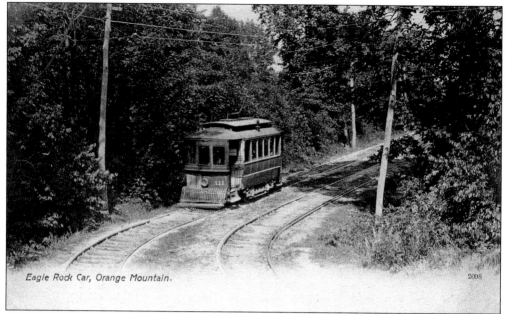

Eagle Rock Car, Orange Mountain. 2098

The trolley continued along Mississippi Avenue and turned up Wilfred Street. It crossed over Valley Way before turning on to Matthew Street (current-day Moore Terrace). Here the trolley is seen about 1902 leaving Moore Terrace and climbing up what would become the narrow section of Nutwold Avenue. It was only a single-track line but ran double track from Mississippi Avenue to just beyond the top of Mountain Avenue.

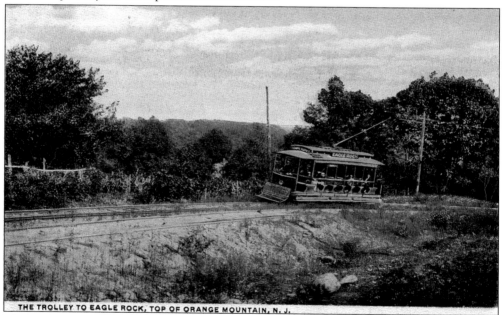

THE TROLLEY TO EAGLE ROCK, TOP OF ORANGE MOUNTAIN, N. J.

The Eagle Rock trolley, seen here about 1908, is rounding the turn at the bottom of present-day Nutwold Avenue. From here, it climbed the steepest part of the grade up Nutwold Avenue. There it made its final turn to the terminus at the City View Hotel on Mountain Avenue. The Eagle Rock trolley ceased operations on April 19, 1924, after 30 years of service. This is a residential neighborhood today.

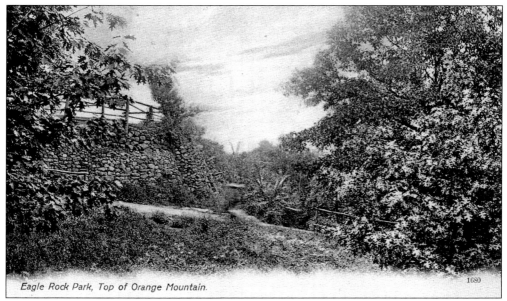

Eagle Rock Park, Top of Orange Mountain.

1680

Here are the same views from nearly identical vantage points separated by about 15 years. The above view is from about 1901 and shows the original stone retaining wall with the old wooden rail fence on top. By this time, it was nearly 30 years old and time and weather had taken their toll. It became unsafe and was crumbling in some spots. When Essex County gained control of Eagle Rock, it began clearing the land and making necessary improvements. In 1907, a new massive 450-foot-long reinforced concrete retaining wall was constructed along the drive at Eagle Rock. It replaced the old wooden fence, which was in a state of disrepair. The view below shows the new wall around 1915, which is still standing today. The wooden rail fence in the foreground below is the 100 steps. Other than the absence of the fence, this scene today is nearly identical and very recognizable.

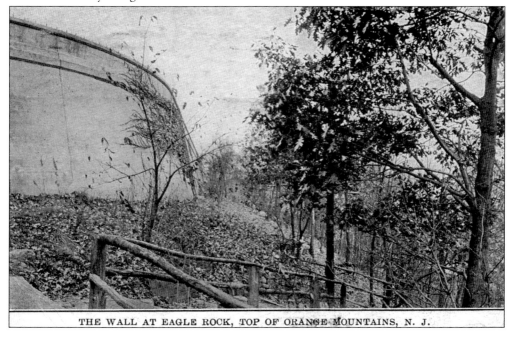

THE WALL AT EAGLE ROCK, TOP OF ORANGE MOUNTAINS, N. J.

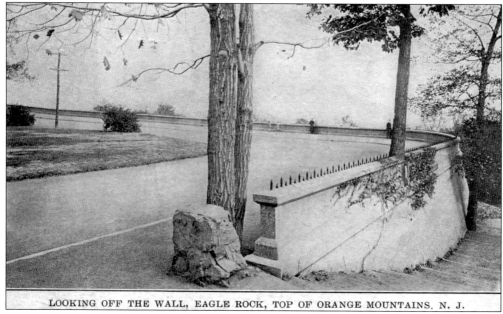

LOOKING OFF THE WALL, EAGLE ROCK, TOP OF ORANGE MOUNTAINS. N. J.

The steps that began on Mountain Avenue across from the City View Hotel and emerged at the top along the new wall are seen here about 1911. Ascending the 100 steps was the only way to reach the destination of Eagle Rock. From this point, one could spend time at Eagle Rock or continue the short distance down Eagle Rock Avenue by foot to nearby Crystal Lake (see chapter 8).

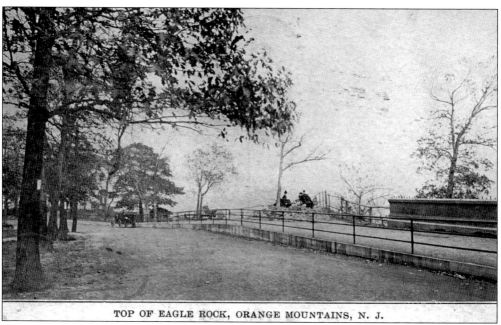

TOP OF EAGLE ROCK, ORANGE MOUNTAINS, N. J.

The other end of the 450-foot-long wall built in 1907 is seen here about 1911. The iron spikes that were embedded in the concrete on top of the new wall (better seen above) were intended for safety purposes. The reasoning was to prevent anyone from climbing over the wall. Even though the 1907 wall has been resurfaced, the spikes on the wall at Eagle Rock today are original.

WHITE HOUSE CASINO, TOP OF EAGLE ROCK, West Orange, N. J.

Essex County's newest improvement at Eagle Rock was the casino when it opened about 1912. It is seen here overlooking Eagle Rock from Mountain Avenue around 1915. The casino was partly an open-air structure with no connection to gambling. In 1917, Thomas Edison conducted top-secret experiments for the U.S. Navy here. It was renovated and has been the Highlawn Pavilion restaurant since December 19, 1986.

TOP OF EAGLE ROCK, West Orange, N. J.

The faint image of the casino is seen peeking out beyond the trees on the right. This 1915 postcard shows the entrance to Eagle Rock at that time. The postcard on the bottom of page 54 would be the view seen looking to the right from this point. Haskell's home the Eyrie is seen to the left and reveals its location in respect to the casino, which is still standing.

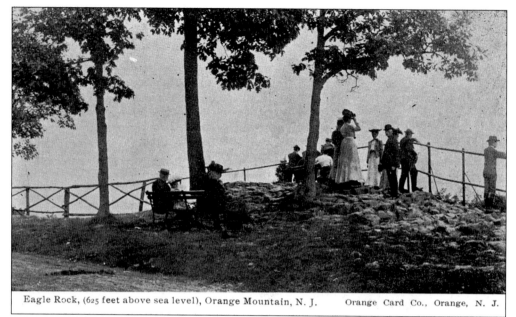

Eagle Rock, (625 feet above sea level), Orange Mountain, N. J. Orange Card Co., Orange, N. J.

At the north end of the 450-foot-long concrete wall was a rocky area with park benches. It is seen here about 1898. It was directly overlooking the high cliff at Eagle Rock. Curious sightseers were protected by both an iron and wooden rail fence. The park benches and wooden rail fence are gone, but this area remains mostly unchanged and is now enclosed by a modern chain-link fence.

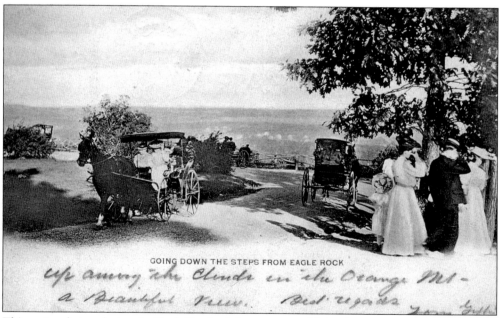

GOING DOWN THE STEPS FROM EAGLE ROCK

This postcard view depicts the Eagle Rock of a bygone peaceful era about 1900. Today the tranquil setting of yesteryear at this exact location has been replaced by a monument to America's most dreadful day. The innocent victims who perished on September 11, 2001, have been forever memorialized here. A permanent September 11 remembrance memorial was constructed on this site at Eagle Rock and dedicated on September 14, 2003.

Eight

THE FORGOTTEN ERA
CRYSTAL LAKE

A team of oxen can be seen dragging cut timber over a narrow path to a lonely farmhouse atop the Orange Mountains. This is probably one of the earliest views, showing a rural Crystal Lake. The postcard is from about 1907, but the scene is much earlier. It is most likely reproduced from a woodcut etching from the 1880s.

ON THE WAY TO CRYSTAL LAKE FROM EAGLE ROCK

The trolley line opened in 1894 but only went as far as the base of the mountain. To reach Crystal Lake, one had to first make the climb to Eagle Rock by foot. The entrance to Crystal Lake was then only a short distance away on Eagle Rock Avenue. The baby carriages of a century ago were apparently worthy of the task, having large-rimmed wheels similar to a bicycle.

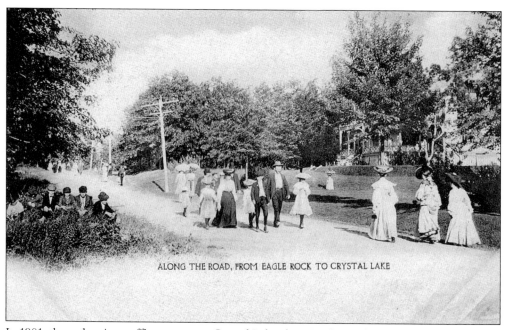

ALONG THE ROAD, FROM EAGLE ROCK TO CRYSTAL LAKE

In 1901, the pedestrian traffic en route to Crystal Lake along Eagle Rock Avenue far outnumbered automobiles. By this time, Crystal Lake and Eagle Rock had both grown into popular weekend destinations. They were only separated by a leisurely stroll of less than a mile. This view is looking east toward the present-day location of the Eagle Rock Diner.

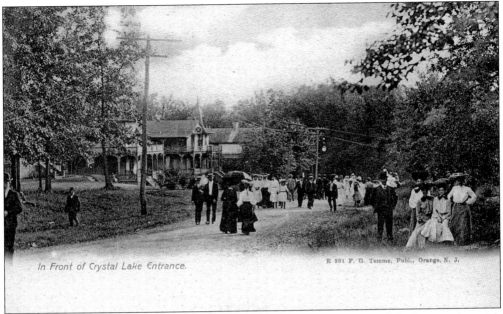

In Front of Crystal Lake Entrance.

E 391 F. G. Temme, Publ., Orange, N. J.

This view from about 1900 is looking west on Eagle Rock Avenue toward the intersection with Prospect Avenue. At the time, three private homes and a hotel stood at the entrance. The last of these homes to survive was only torn down in 2007. In the 1970s, a tall communication tower was erected behind this house. A new building now occupies the site of the former house with the same tower.

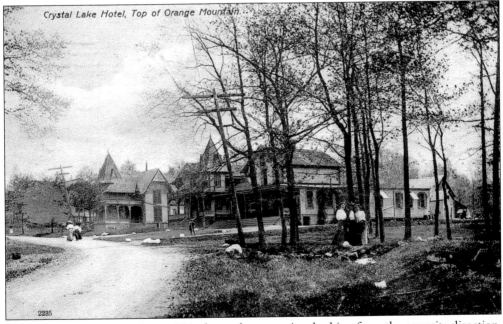

Crystal Lake Hotel, Top of Orange Mountain.

2235

This postcard, also from about 1900, shows the same view looking from the opposite direction. Here the entrance to Crystal Lake and the three houses and the hotel and can be seen looking east from the corner of Prospect Avenue. Today this location on Eagle Rock Avenue is the entrance to the parking lot for the bowling alley.

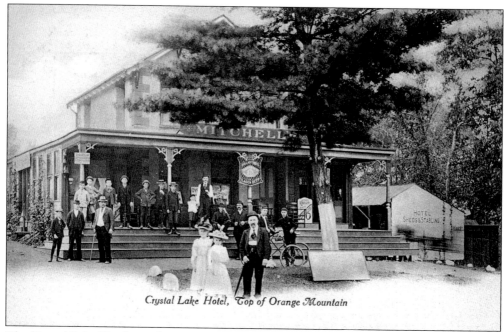

Crystal Lake Hotel, Top of Orange Mountain

The Crystal Lake Hotel was shown on maps as early as 1890. This view from about 1901 shows the hotel when the Crystal Lake Hotel was also known as Mitchell's Hotel. The hotel stables can be seen in the wooden shed to the right. The owner, Hugh Mitchell, is presumably standing in the front and posing with the two young girls in period dress.

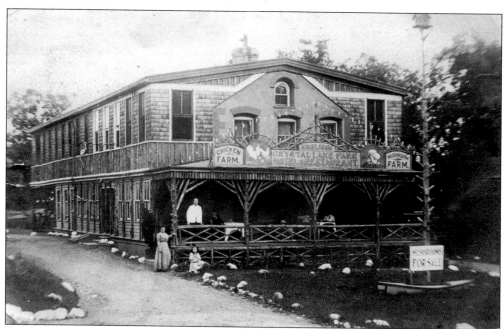

By 1910, the hotel had an addition to the second floor. It also added a chicken and mushroom farm. The Crystal Lake Park Hotel and Restaurant was also now owned by John English. It most likely changed owners and names several times before it burned to the ground on May 10, 1936, as the Crystal Lake Inn. It was reported that faulty wiring caused $20,000 worth of damage.

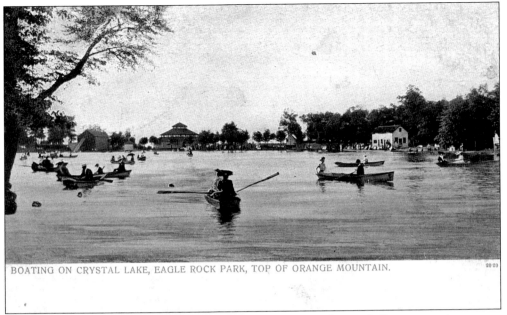

BOATING ON CRYSTAL LAKE, EAGLE ROCK PARK, TOP OF ORANGE MOUNTAIN.

The building to the extreme left next to the carousel is an icehouse. It first appeared on a map in 1890. It also was seen in a 25-second movie called *Hockey Match on the Ice*, by Thomas Edison, filmed on February 24, 1898. That film was shot very near this exact perspective. At the time, the icehouse was the only building at Crystal Lake.

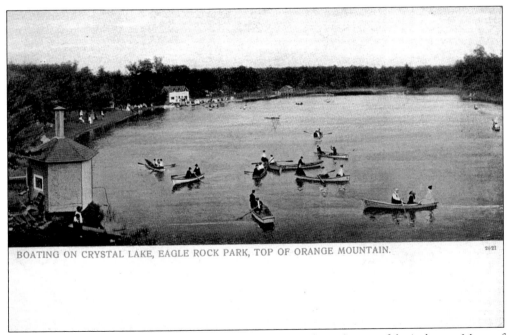

BOATING ON CRYSTAL LAKE, EAGLE ROCK PARK, TOP OF ORANGE MOUNTAIN.

This view from about 1902 is looking back across the lake from the top of the icehouse. Many of the Crystal Lake postcards list the location as Eagle Rock. This was probably done to emphasize how close both parks were to one another. On the distant shore of the lake is where the present-day bowling alley is located. The building to the left appears to be a small smokehouse.

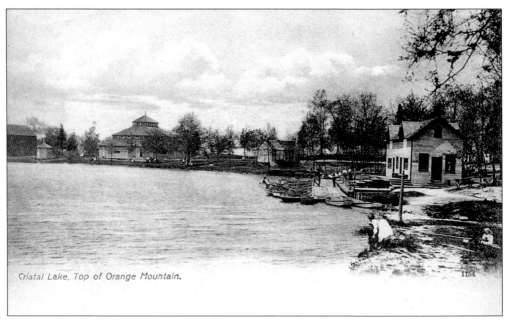

Cristal Lake, Top of Orange Mountain.

The carousel seen left of center first appeared on maps in 1904. The amusement park was fast growing in popularity. The thrill of riding the carousel probably attracted more visitors to Crystal Lake than Eagle Rock. In order to get there, all had to pass through Eagle Rock first. The boathouse and dock to the right were also built about the same time.

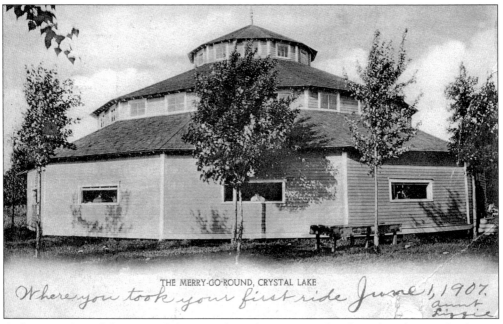

THE MERRY-GO-ROUND, CRYSTAL LAKE

Where you took your first ride June 1, 1907. aunt Lizzie

A close-up view of the carousel does not show the exquisite detail inside. The wooden horses used for the ride were reported to be hand carved in Italy. In the 1930s, Jim Sheeran, future insurance commissioner of New Jersey and mayor of West Orange, worked the merry-go-round at Crystal Lake. Sheeran also became a decorated World War II combat veteran. He died in 2007 at age 84.

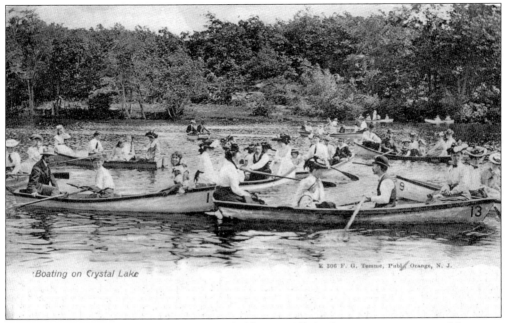

Boating on Crystal Lake

E 306 F. G. Temme, Publ., Orange, N. J.

The lake itself is comprised of four and a half acres. All the boaters seem to crowd into one location as they pose for the photographer about 1904. The flat-bottom rowboats could hold up to four people. Boating at Crystal Lake had become a popular outdoor weekend activity. It was also considered safe because the lake only reported to have a maximum depth of four feet.

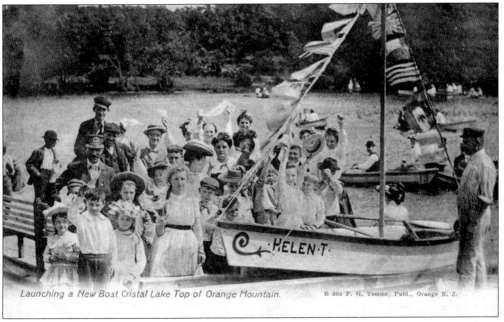

Launching a New Boat Cristal Lake Top of Orange Mountain.

E 305 F. G. Temme, Publ., Orange N. J.

The rental boats were numbered for easy identification. Boats named after women may have been privately owned or special rentals. Launching a new boat certainly generated excitement for the children. The gentleman with the derby, rowing boat 13 in the previous image, appears to be the same person rowing boat 13 here. Both photographs were most likely taken only a short time apart and on the same day.

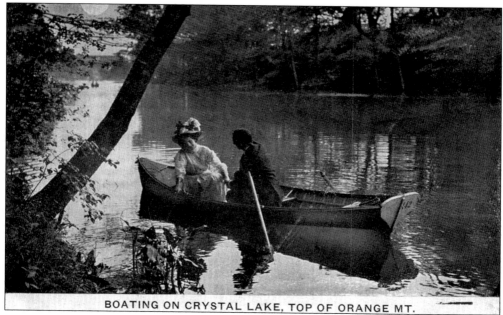

BOATING ON CRYSTAL LAKE, TOP OF ORANGE MT.

No doubt, boating on the lake spawned many a romance. One such relationship allegedly existed between two Crystal Lake employees. Beatrice was an attractive young lady working in the business office. She and Gordon, who tended to the boats, found their way to the end of the lake after hours on many a moonlit night.

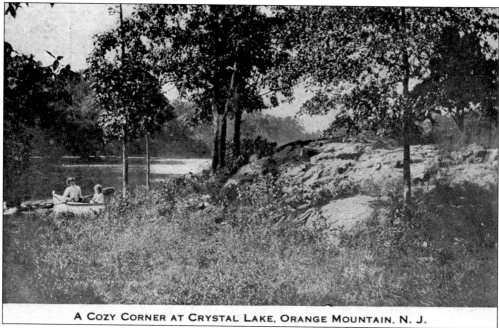

A COZY CORNER AT CRYSTAL LAKE, ORANGE MOUNTAIN, N. J.

One such romance actually went beyond mere allegations. In 1922, Crystal Lake was owned by the DiMarzo family, who emigrated from Italy in 1902. Their son William met another immigrant, Bridget Cummingham from Ireland, that summer at the lake. She was a domestic servant who worked at nearby Llewellyn Park. The two eventually married. In 1937, the DiMarzo family lost the Crystal Lake property because of the Depression.

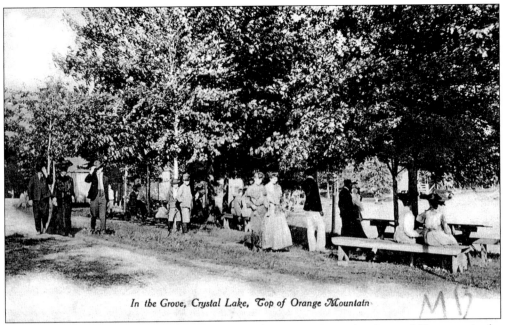

In the Grove, Crystal Lake, Top of Orange Mountain

Boating was a popular activity but only lasted a short time. An entire day could be spent in the small green pasture known as the grove. It was an area reserved for family picnics where food could be purchased. The day usually peaked in the afternoon with some form of entertainment. Tony Galento, the prizefighter, and the big band sound of Harry James performed there during the 1930s.

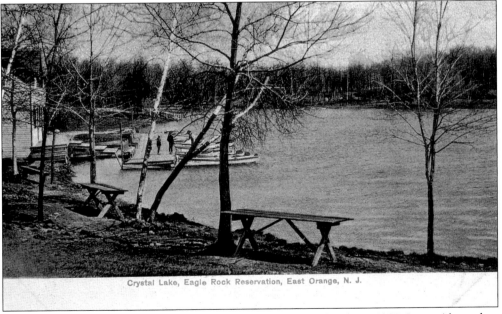

Crystal Lake, Eagle Rock Reservation, East Orange, N. J.

This is a fall scene in the grove along the shore of Crystal Lake about 1907. It provides a clear view of the boathouse dock. This postcard title displays another example of an attempt to closely associate Crystal Lake to the nearby Eagle Rock Reservation. Postcard producers often generalized and were vague in listing exact locations, as this one incorrectly shows East Orange.

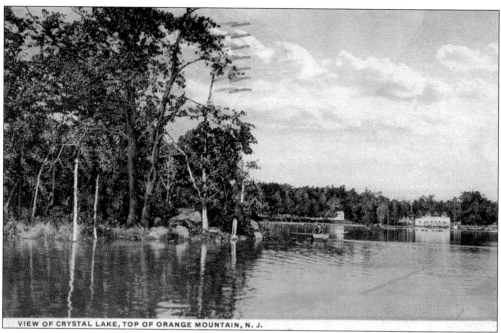

VIEW OF CRYSTAL LAKE, TOP OF ORANGE MOUNTAIN, N. J.

Here is a glimpse of the pristine waters of the spring feeding the lake about 1907. Despite being a shallow lake, swimming was not popular or permitted at the time. This changed in the 1930s when a pool was added at this end of the lake. Water from the lake flowed to the pool. Crystal Lake pool was the second largest in the area, only surpassed by the Olympic Park pool in Irvington.

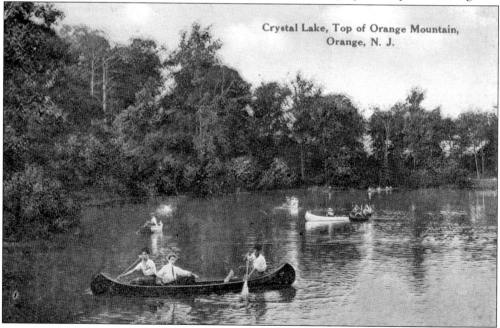

Crystal Lake, Top of Orange Mountain, Orange, N. J.

By the 1920s, Crystal Lake offered canoe rentals in addition to boats. Canoes seemed to be better suited for exploring rivers and streams. They were considered more stylish than practical on the lake and required more athletic ability to use. Working in tandem, two people in the front and rear could display their quick skillful maneuvers in open water.

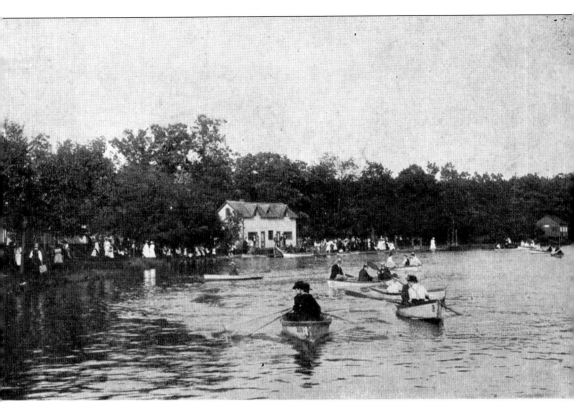

ystal Lake, Orange Mountain, N. J.—No. 42. Orange Card Co., Orange, N.

Crystal Lake was not without drowning and other near tragedies. Perhaps the most compelling occurred in 1915. A young schoolgirl named Sophie Tancke of Alden Street in Orange threatened to commit suicide at the lake. She became distraught after being unable to pay a $1.50 debt to her school principal. Chester Taylor, principal of the Cleveland Street School in Orange, requested the money she was supposed to have received for the sale of chocolate and cocoa. It was a fund-raiser that Tancke was forbidden to participate in by her parents. This was unknown to school officials. She was unable to come up with the money and had told a friend that she would drown herself in Crystal Lake. When she had been missing for several days, the West Orange Police dredged Crystal Lake, fearful that she may have acted on her threat. However, she turned up alive some days later hiding out in a candy store in Maplewood. She was found with a bag of neckties that she was attempting to trade for lodging.

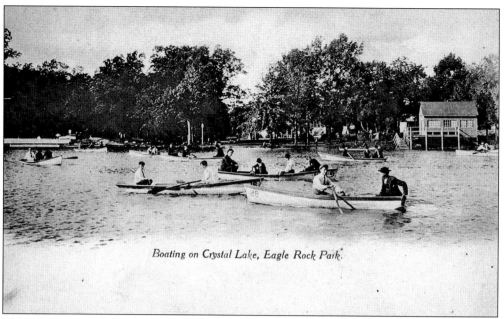

Boating on Crystal Lake, Eagle Rock Park.

This 1901 postcard shows a private clubhouse to the right that existed at Crystal Lake. This framed structure was used primarily as a clubhouse for ice-skaters. It was reported in 1906 that this club served tea on Saturday afternoons during the winter months. It also hosted a number of other social events during the season.

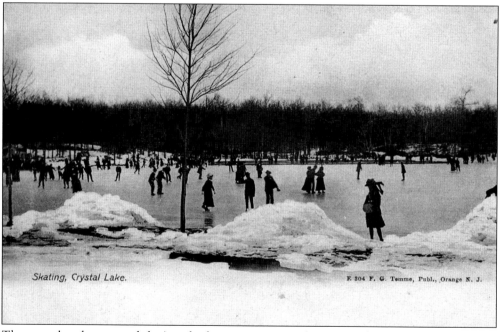

Skating, Crystal Lake.

F. 304 F. G. Temme, Publ., Orange N. J.

The same boathouse used during the hot summer months was used as protection from the elements for ice-skaters in the winter. An old pot-bellied stove was brought in to provide heat and create a warm, cozy atmosphere for sipping hot chocolate and indoor socializing. The cold, gray skies brought scores of people on weekends to the frozen lake to experience this enjoyable aspect of wintertime.

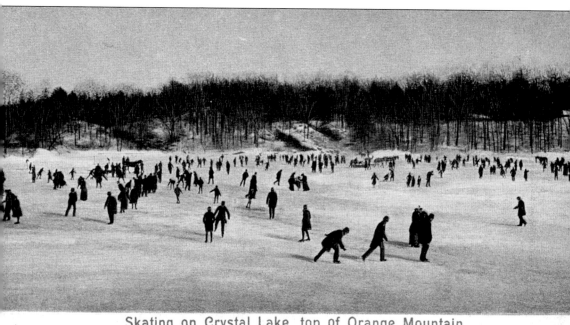

Skating on Crystal Lake, top of Orange Mountain

As early as 1895, Hugh Mitchell, the owner of Crystal Lake, promoted ice-skating. The winter scene here is from about 1907. By the 1930s, it became so popular that skating exhibitions were regularly held. On February 7, 1930, a group of international skating stars inaugurated an eastern-state tour by holding an event at Crystal Lake. The world figure-skating champion at the time, Karl Schafer, performed on that day. A wooden frame plank extended from the boathouse to the frozen lake. A huge oval perimeter was marked by 50-gallon drums that controlled the direction of flow. The faster skaters stayed to the outside, and the inside was reserved for a more leisurely pace. It also was not uncommon for hockey games to be at the far end of the lake away from the crowds. Barrel jumping also was a means by which racing skills could be showcased and often occurred on Sunday afternoons during the 1930s and 1940s.

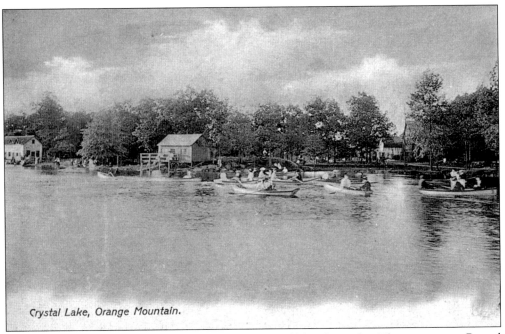

Crystal Lake, Orange Mountain.

This view from about 1904 is looking north and not at all familiar today. The entrance to Crystal Lake is straight ahead to the right. The private clubhouse is to the left, and the boathouse is to the extreme left. All these structures are gone today. The lake remains, and the present-day bowling alley and parking lot are to the right.

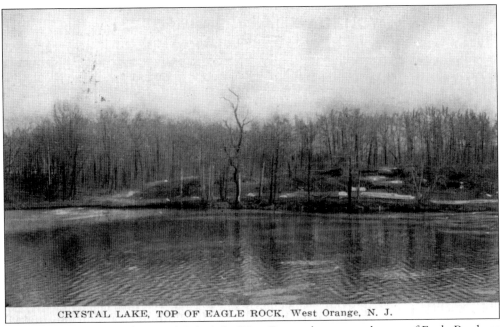

CRYSTAL LAKE, TOP OF EAGLE ROCK, West Orange, N. J.

As previously mentioned, Crystal Lake is in West Orange but not at the top of Eagle Rock, as stated by the title of this postcard from about 1915. The lake has always been an excellent spot for fishing and still continues to be so to this day. Up to nine different species of fish have been recorded there, including trout, large- and small-mouth bass, and even goldfish.

114

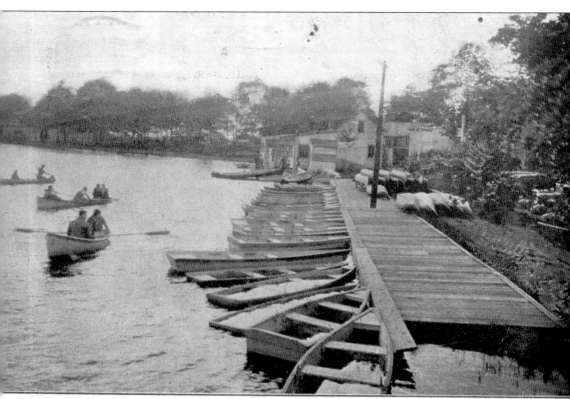

Boat House, Crystal Lake Park, Eagle Rock Avenue, West Orange, N. J.

Each August during the 1920s and early 1930s, West Orange commissioner George V. McDonough sponsored an annual outing at Crystal Lake. On what became known as McDonough Day, kids were picked up at the local playgrounds and bused to the lake. A day of fun at the lake helped distract them from the dark days of the Depression. They were treated to food, boating, entertainment, and unlimited rides at the park, which lasted into the early evening. Joe Byrne (see page 26), who was the first supervisor of West Orange playgrounds, was also instrumental in helping organize these outings at the lake until his death in 1928. McDonough Days at Crystal Lake was made possible by the generosity of the DiMarzo family, who owned Crystal Lake at the time. It is fondly remembered by older residents who recall the Crystal Lake of a forgotten era.

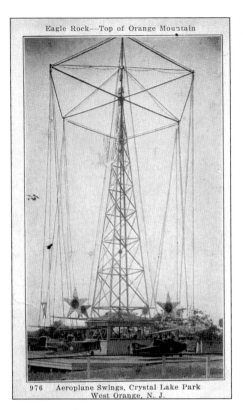

A postcard around 1925 offers a close-up view of the popular airplane swing ride at the Crystal Lake Amusement Park. Steel cables were suspended from a tower and connected to the planes. When it rotated, the planes became airborne in a circular pattern. It offered children the sensation of an airplane ride at a time when they could only dream of flying in an actual airplane.

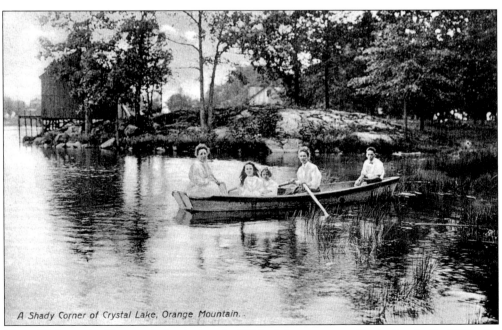

A Shady Corner of Crystal Lake, Orange Mountain.

Crystal Lake peaked in popularity during the 1930s. It began to steadily decline in the 1950s. By the late 1970s, the property was abandoned and neglected. In the 1990s, a developer refurbished the lake and adjoining properties when building town houses on the west shore.

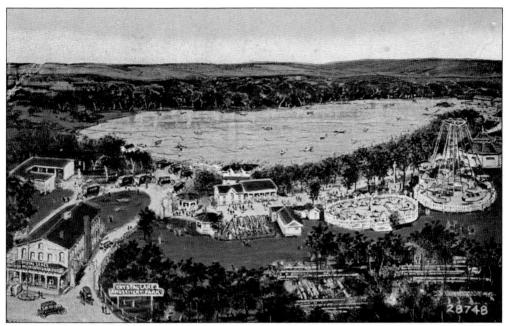

This bird's-eye view from about 1930 of Crystal Lake shows the entire layout of the 5.6-acre site. The entrance and hotel on Eagle Rock Avenue are seen to the left. The roof of the boathouse peeks above the treeline on the lakeshore in the center. The amusements occupy the center foreground with the airplane swings towering above the carousel to the right.

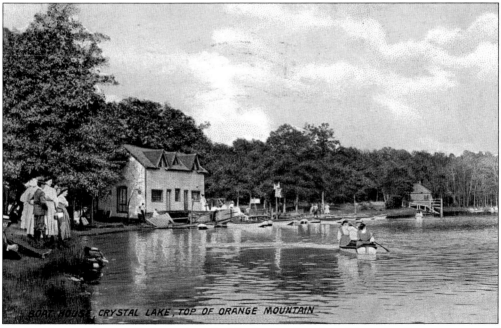

The boathouse was centrally located on the lakeshore at the edge of the grove. It was constructed around 1900 when the property beyond the original hotel was expanded with an amusement area. On weekends and especially during the summer months, it was a flurry of activity. From here blossomed daily social interchanges and countless young relationships.

117

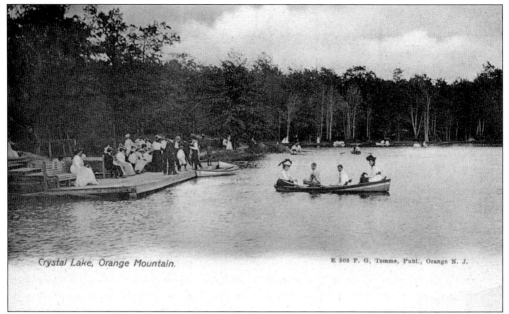

Crystal Lake, Orange Mountain. E 303 F. G. Temme, Publ., Orange N. J.

Crystal Lake undoubtedly was a place for men and women to proudly display their latest fashions of the day, particularly for women, who showcased the varying styles of their ankle-length skirts and large, floppy hats. As seen in many of the postcards, the fashions were not just limited to the shore. The boaters often included fashionable, well-dressed men, women, and children in their Sunday best.

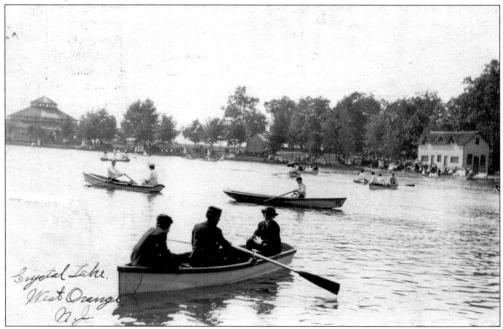

Crystal Lake.
West Orange
N.J.

Pictured here is a view across Crystal Lake about 1908. The boathouse is the white building to the right, and the carousel is the last building on the left. Crystal Lake was entering its golden age. One hundred years later, all the buildings are gone and only the lake remains at the end of a parking lot next to a bowling alley as the only link to West Orange's truly forgotten era.

Nine

BEHOLD NATURE'S BEAUTY
LLEWELLYN PARK

This postcard from about 1901 captures the essence of the pristine state of West Orange's Llewellyn Park. It offers a glimpse of the undisturbed natural beauty of yesteryear that was once abundant in the Orange Mountains. It bears witness to the vision of the founder, Llewellyn Haskell, who loved nature. The narrow, winding roads are the same today as Haskell laid them out at the time of the park's early development.

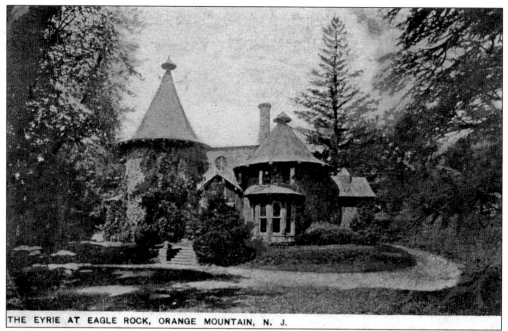

THE EYRIE AT EAGLE ROCK, ORANGE MOUNTAIN, N. J.

Llewellyn Haskell first visited the Orange Mountains in 1853. It was here that he made his first purchase of land at what today is Eagle Rock. In 1854, he built his home the Eyrie on the foundation of an old farmhouse. This is where he envisioned a park surrounded by the scenic natural beauty of the mountain with his house serving as the entrance on a grand boulevard.

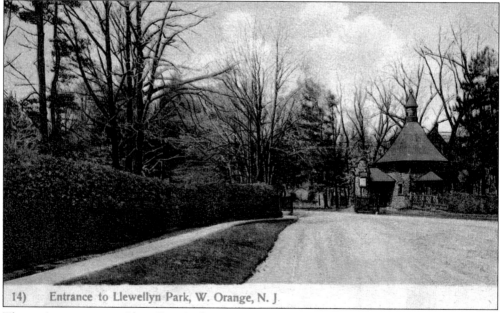

14) Entrance to Llewellyn Park, W. Orange, N. J.

The main entrance to Llewellyn Park is on Main Street by Park Avenue. The current-day gatehouse is the original that was constructed about 1860. It was constructed as a replica of Haskell's home the Eyrie at Eagle Rock. Dietrich Everett, the stonemason on the Eyrie, was the park's first gatekeeper. This structure at the entrance has been the subject of dozens of postcards. This postcard is from around 1901.

120

Beyond the main entrance is a picturesque ravine named the Glens by Haskell. A rapidly running brook of pure springwater is surrounded by a dense mass of trees. This area was left mostly undisturbed with variously shaped rocks peering out of the ground. This natural state preserved by the foliage and deep shape best represents the realization of Haskell's vision of today's park that bears his name.

Orson D. Munn at one time was the publisher of *Scientific American*, which was a journal known for its outstanding presentation of scientific findings to the public. His home in Llewellyn Park, built about 1870, was known as the Terraces. This postcard from around 1904 shows the view from the house of the neatly manicured terraced flower gardens on the hillside. By 1911, his son Charles Munn owned the property.

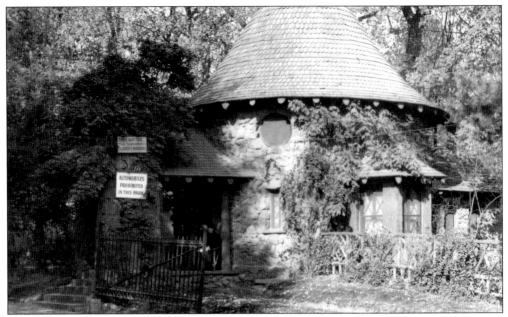

This view from about 1905 of the gatehouse displays an interesting sign reflective of the times. It reads, "Automobiles Prohibited In This Park." The smaller sign reads, "Closed on Sundays." At the dawn of the 20th century, the automobile was just an emerging technology and not widely accepted. The policy was amended as affluent park residents soon became owners of some of the first automobiles in West Orange.

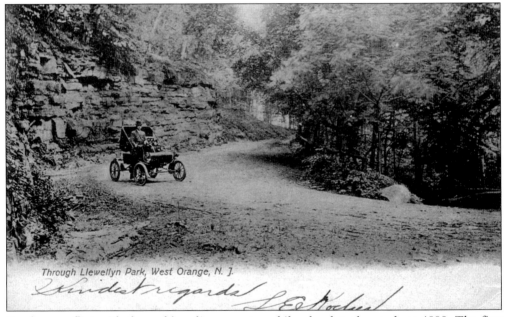

Through Llewellyn Park, West Orange, N. J.

Surely a conflict with the park's policy on automobiles developed as early as 1899. The first automobile in West Orange was reportedly owned by Llewellyn Park resident Arthur J. Moulton. On September 5, 1899, he appeared in a Dion Bouton machine powered by a gasoline engine. The cost of the vehicle was $1,000. It is not known if he and his automobile are featured in this postcard from about 1900.

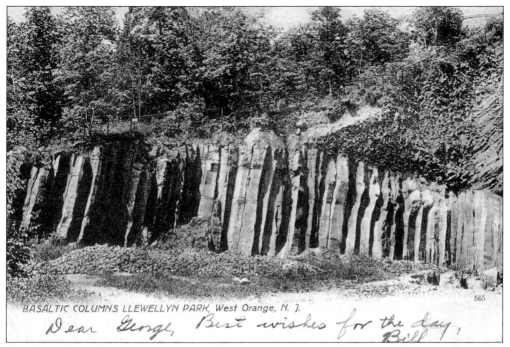

BASALTIC COLUMNS LLEWELLYN PARK, West Orange, N. J.

Dear George, Best wishes for the day, Bill

At various times, there were as many as three quarries in West Orange producing sandstone for building purposes and for headstones in local cemeteries. Llewellyn Haskell offered his quarry in Llewellyn Park to provide stone for the building of St. John's Church in Orange in 1866.

View of Orange from the Mountain

This is a view from the eastern slope of the first mountain as seen from Llewellyn Park about 1907. It is looking east toward Orange. The steeple of St. John's Church and the recognizable dome of Columbus Hall can be seen on the horizon. St. John's Church opened on October 10, 1869, in part, thanks to Haskell's generous contribution from his Llewellyn Park quarry.

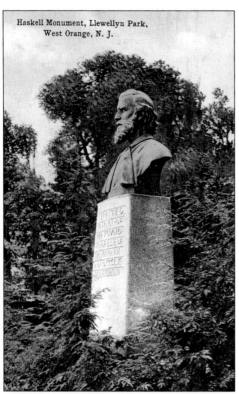

Haskell Monument, Llewellyn Park,
West Orange, N. J.

In 1875, three years after his death, former associates and townsmen procured a subscription of $2,500 to erect a bronze bust of Llewellyn Haskell. It was set atop a concrete pedestal overlooking the entrance to the park, where it remains today. He was born on January 4, 1815, in New Gloucester, Maine, and died on May 31, 1972, in Santa Barbara, California. This postcard view is from about 1911.

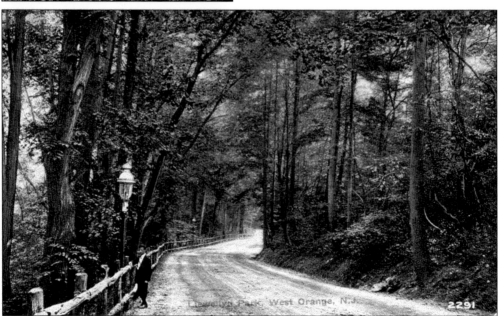

From Haskell's first house at Eagle Rock was spawned the concept of Llewellyn Park. He conceived the vision of a large residence park incorporating the eastern slope of the mountain just below Eagle Rock. His plan was to artistically develop winding roads through rustic rambles into attractive sites for those having ample means to further adorn the landscape with ornate dwellings. Llewellyn Park today remains mostly unchanged from Haskell's original dream.

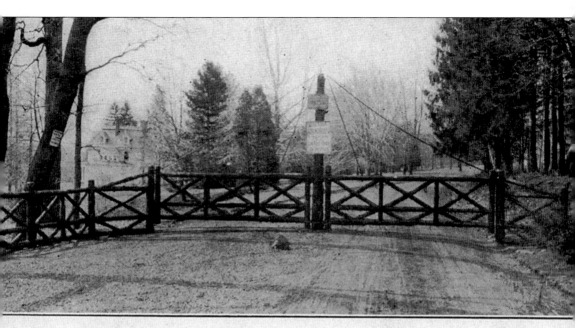

NORTH ENTRANCE TO LLEWELLYN PARK, WEST ORANGE, N. J.
Gates Each 14 Feet Long and Hung From Centre Post
MADE BY LLEWELLYN WHEELER, 206 ALDEN PLACE, ORANGE, N. J.

John Wheeler came to the United States from Switzerland at an early age. He was a builder of rustic structures and an expert in design and workmanship. After settling in Orange, he did a great deal of work for Haskell in Llewellyn Park. Many of the artistic and rustic railings and fences within the park were originally built by him. Wheeler also did work for Llewellyn Park resident O. D. Munn. One of Wheeler's six sons, Llewellyn Wheeler, continued in his father's business in building rustic structures. Presumably Llewellyn Wheeler was named after Haskell because of the close association and friendship his father had with Haskell. This gate at the north entrance to Llewellyn Park opposite Mountain Avenue on Eagle Rock Avenue was built by Llewellyn Wheeler. It is seen here about 1900. This gate also resembled other gates that were once located at other Llewellyn Park entrances. Most likely, they were all built by John Wheeler. None of these gates are in existence today, and the only entrance currently used for Llewellyn Park is on Main Street.

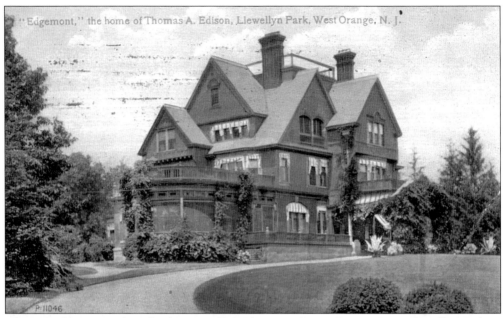

"Edgemont," the home of Thomas A. Edison, Llewellyn Park, West Orange, N. J.

P. 11046

Thomas Edison moved to this home, called Glenmont (not Edgemont), in Llewellyn Park in 1886. The following year, he constructed his laboratory on Main Street. He lived and worked in West Orange until his death in 1931. Over the years, Llewellyn Park has seen its share of famous people. On July 6, 1871, Pres. Ulysses S. Grant rode through Llewellyn Park accompanied by Frederick Frelinghuysen, without any reception or fanfare.

The author's father, James Fagan Jr., is standing at the entrance to Llewellyn Park opposite Valley Way about 1934. He lived nearby and was the third generation to live in West Orange. Mina Edison, Thomas Edison's second wife, often parked her electric automobile here while shopping nearby. On occasion, she would invite Fagan for a ride through the park. He and his friends also once met a visiting Eleanor Roosevelt at Llewellyn Park.

Wildmont Lodge was the home of renowned architect Alexander Jackson Davis (1803–1892). Davis is best known for his buildings in the American Gothic Revival style. His former home is now gone but was once located opposite the present-day entrance to the Eagle Rock Reservation. It sat on top of the mountain ridge on what would today be overlooking the Crown View Manor luxury condominiums. Davis designed several homes in Llewellyn Park that still are standing today. He also designed Haskell's home the Eyrie as well as the gatehouse at Llewellyn Park. It is perhaps the best example of his work that remains as a surviving link to the common beginnings of both Eagle Rock and Llewellyn Park. Davis was also known for his work in both the Greek Revival style and Italian villa style. Over the years, the whereabouts of Davis's grave became lost to history. In 1969, it was discovered in a Bloomfield cemetery, where he was buried in January 1892.

ACROSS AMERICA, PEOPLE ARE DISCOVERING SOMETHING WONDERFUL. *THEIR HERITAGE.*

Arcadia Publishing is the leading local history publisher in the United States. With more than 3,000 titles in print and hundreds of new titles released every year, Arcadia has extensive specialized experience chronicling the history of communities and celebrating America's hidden stories, bringing to life the people, places, and events from the past. To discover the history of other communities across the nation, please visit:

www.arcadiapublishing.com

Customized search tools allow you to find regional history books about the town where you grew up, the cities where your friends and family live, the town where your parents met, or even that retirement spot you've been dreaming about.